LEGENDARY LOCALS

OF

ANDOVER

MASSACHUSETTS

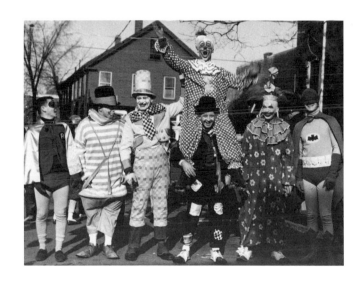

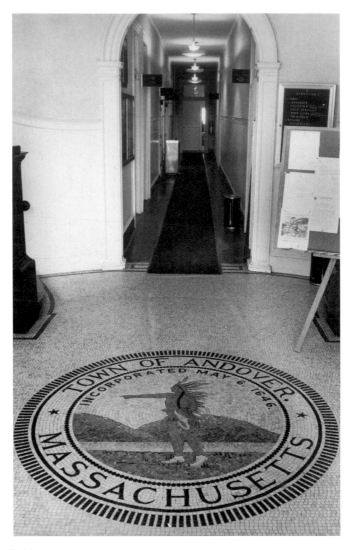

Andover Town Seal
Created c. 1900, this tile mosaic depicts Cutshamache, a sagamore of Massachusetts, holding in his left hand a pouch containing £6, with a coat over his left arm. This was the full payment given by the settlers of Andover, briefly called Cochichawicke, for the land that is now Andover, North Andover, and part of South Lawrence. Cutshamache preserved for an Indian named Roger the right to fish, plus four acres of land, as long as he did not steal from the settlers. Presumably, Cutshamache is pointing to the land being sold. The seal is in the ground floor entrance of the old town hall, now called the Andover Town House. (Photograph by Richard Graber, courtesy of Jennifer Graber.)

Page 1: **Firefighter's Santa Parade, 1966**
For almost 60 years, the firefighters of Andover and the Andover Firefighters Relief Association have organized the Andover Santa Parade. It is a tradition that is dear to the hearts of the people in town. Each year, someone who embodies community spirit and excellence is chosen to be grand marshal. Shown here are, from left to right, Andover firefighters James Cassidy, Harold Hayes, Edward Palenski, Richard Merola (top), Alfred Desrosier, Walter Potvin, and Harold Wright. They are festively dressed to hand out candy to the children at the parade. (Courtesy of Harold Hayes.)

LEGENDARY LOCALS
OF
ANDOVER
MASSACHUSETTS

BILL DALTON AND KATHARINE DALTON

LEGENDARY
LOCALS

Legendary Locals is an imprint of Arcadia Publishing
Charleston, South Carolina

Printed in the United States of America

Library of Congress Control Number: 2013933407

For all general information, please contact Arcadia Publishing:
Telephone 843-853-2070
Fax 843-853-0044
E-mail sales@arcadiapublishing.com
For customer service and orders:
Toll-Free 1-888-313-2665

Visit us on the Internet at www.arcadiapublishing.com

Dedication
To our children, Bill, Jack, Abigail, Kelsey, and Grant; our grandchildren, MacKenzie, Elena, Will, Caroline, JD, Carly, and Chase; and to the townspeople of Andover, past and present.

On the Front Cover: Clockwise from top left:
Frances McClellan, enterprising widow (Courtesy of Robert Stefani; see page 114), Jane and Benjamin Pierce, First Lady and son (Courtesy of Pierce Brigade; see page 117), Allen Hinton, former slave, businessman (Courtesy of Andover Historical Society; see page 38), Bernice M. Haggerty, historian (Courtesy of Bernice M. Haggerty; see page 24), Barry and Thomas Low, musicians, coach (Courtesy of Low family; see page 123), Charles E. Abbot, physician, historian (Courtesy of Andover Historical Society; see page 77), Col. and Mrs. Edward M. Harris, Army officer, town official (Courtesy of Harris family; see page 72), Alice Buck, conservationist (Courtesy of Andover Historical Society; see page 98), Theodore "Ted" Boudreau, teacher and coach (Courtesy of Mrs. Betty Boudreau; see page 49).

On the Back Cover: From left to right: Norma Gammon, town official and historian (Courtesy of the Andover Historical Society; see page 87), Loscutoff family (Courtesy of Lynn Loscutoff; see page 122).

CONTENTS

ACKNOWLEDGMENTS

The authors thank all the people who took the time to delve through old scrapbooks, frayed boxes, overburdened garages, and dusty attics to send us many of the photographs the reader will see in this book. To name just a few: James (Jim) S. Batchelder, the Deyermond family, Harris family, Coburn family, Charles McCullom family, Fred McCollum family, Alice and Phidias Dantos, Kenneth Maglio, Barry Low, Robert Stefani, and John and Margaret Kimball. Special thanks to Juliet Haynes Mofford, Joan Patrakis, Gail Ralston, and Michael Burke, director of the Andover Department of Veterans Services, each of whom helped in many ways.

Both Paige Roberts, of the Phillips Academy Special Collections, and Kimberly Lynn, a dogged researcher at Memorial Hall Public Library, provided crucial help. Elaine Clements and the staff at the Andover Historical Society (AHS) were invaluable. Amy Sweeney and Carl Russo at the *Eagle-Tribune* and *Andover Townsman* were lifesavers. Mark Spencer, who has spent decades photographing legendary locals of Andover and was responsible for starting the Citizens who Care Award with the Rotary Club of Andover in 1995, provided his assistance as well and was always courteous and speedy in sharing his images. We particularly thank Jennifer Graber, who opened her home to us and let us look through her father's wonderful photographs, many of which appear in these pages.

INTRODUCTION

In 1634, Andover's fertile soil and numerous waterways inspired the Great and General Court of Massachusetts to set aside the land for future settlement. The town was incorporated on May 6, 1646, and 24 families were settled by 1650. The town's name comes from Andover, England, where many of the settlers originated.

The earliest relationship between the English settlers and the indigenous Indian tribes was good, perhaps because, between 1614 and 1619, just before the first English settlers arrived, epidemics killed as many as 75 percent of the Indians in New England. As the Indian population rebounded and more English settlers arrived, conflicts arose. This was compounded by wars between England and France, known in the colonies as the French and Indian Wars (1689–1773). An Andover man, Joseph Frye, served with distinction in the later decades of these wars. In addition to being a capable leader of men, Frye proved to be an escape artist, twice narrowly avoiding being killed by Indians. By the time of the Revolutionary War, Frye, now a general, was awarded the land that is now Fryeburg, Maine.

There were three local Indian skirmishes with loss of life. In 1672, young Joseph Abbot was killed and his brother Timothy taken prisoner (he was released months later). In 1689, two other Andover brothers were killed. A more significant attack occurred when a band of Indians attacked the village. They were seeking revenge on the cowardly Pascoe Chubb, one of the town's first villains, who had murdered two chiefs and two other Indians while under a flag of truce in the fort he commanded. Both Chubb and his wife were killed, along with at least one other person.

During the witch hysteria of the late 17th century, no town suffered more than Andover. In all, forty people were accused, eight convicted, and three executed: Martha Carrier, Mary Parker, and Samuel Wardwell. Elderly Ann Foster died in jail. The 76-year-old minister in Andover, Francis Dane, fought against the persecution of alleged witches, which may have contributed to the arrest and conviction of his daughter, Abigail Dane Faulkner. After 13 weeks in jail, she was released due to her pregnancy. Another daughter, Elizabeth Dane Johnson, was acquitted after five months in jail. However, her daughter, Elizabeth, confessed and was released only when her grandfather, Francis Dane, testified that she was "simplish" at best.

In 1708, the first signs of a schism in Andover occurred when the South Parish became a legal entity. The founders of the South Parish, and therefore the founders of present-day Andover, were John Abbot, Joseph Ballard, George Abbot, Francis Dane (son of the minister), John Russ, and William Lovejoy. The final division of the two towns did not occur until 1855. In 1827, West Parish was carved out of the South Parish, but it was purely an ecclesiastical parish with no attempt made to create a separate town. Congregationalism was the legally established religion throughout Massachusetts until 1831. Although many of the first settlers came to New England seeking religious freedom, they had in mind the right to worship in their own church rather than the established church in England. The earliest Massachusetts colonists were intolerant of other churches or of attempts to make any alterations to their own church.

The Andover militia was active in the Revolutionary War (1775–1783), notably at the Battle of Bunker Hill, where several Andover men, led in the field by Capt. Isaac Abbot, were in the middle of the fight. During the war, a powder mill was built by Samuel Phillips Jr., a man from a prominent family, to provide much-needed gunpowder to the Continental Army. The mill blew up three times, with loss of life. In 1807, the facility was purchased by William Marland, and it became a textile mill, one of the first in the nation.

Andover, a leader in education, had its first public grammar school by 1700. Even before Phillips Academy's existence, 34 Andover natives had graduated from Harvard. In 1778, Samuel Phillips Jr. founded Phillips Academy, with help from his friend Eliphalet Pearson, the school's first principal. On November 5, 1789,

seven months after his inauguration, President Washington visited Andover. After breakfast at Abbot's Tavern, he had lunch with Phillips. Washington, who was childless, was so impressed that he influenced a nephew and six grandnephews to attend the academy.

In 1808, the Andover Theological Seminary moved next to Phillips Academy and, until 1908, when the seminary left Andover, the campuses of both schools intertwined, sharing several trustees during most of those years. Leading citizens of Andover were good to Phillips Academy with their time and money, serving as trustees and making generous donations and bequests. When the seminary left Andover, the academy purchased its buildings. Thomas Bulfinch was the architect of some of the schools' most beautiful buildings; alumnus and philanthropist Thomas Cochran donated the money to help Phillips Academy grow into the 20th century, including funding the Cochran Bird Sanctuary; and the landscape architecture firm formerly controlled by alumnus Frederick Law Olmsted worked on the design of the campus. The result is the beautiful campus that exists today.

The bond between Andover and Phillips Academy has historically been strong and remains so today. A large number of Andover's children have graduated from the school, and many faculty and staff members have been leading citizens of the town. The Addison Gallery of American Art, the Peabody Museum of Archeology, and the Cochran Bird Sanctuary are available to people from the town.

President Washington was one of five presidents who visited Andover. The others were Presidents Jackson, Pierce, Taft, Theodore Roosevelt, and Coolidge. During the school's bicentennial, Vice Pres. George H.W. Bush paid a visit. Both Presidents Bush are alumni of Phillips Academy.

In 1829, Sarah Abbot provided seed money to fund Abbot Female Seminary. It, too, was heavily supported by Andover citizens, who gave freely of their time and money. The female seminary changed its name to Abbot Academy and merged with Phillips Academy in 1973. Punchard Free School, the town's first public secondary school, opened in 1856. In 1957, it became Andover High School. St. Augustine's School opened in 1914 and moved to its present facility in 1918; an addition was completed in 1961. It has always been under the direction of the Sisters of Notre Dame de Namur. Cynthia E. Pike opened Pike School in her house in 1926, with six students. Today, Pike is a private elementary school with more than 430 students, many of whom transition to Phillips Academy.

Taverns existed almost from the beginning of the town but were strictly controlled. A few gristmills and sawmills were established early on. Beginning in the latter part of the 18th century, other kinds of mills sprouted up along the rivers and brooks of Andover from Ballardvale to Shawsheen, and the agrarian economy became more mixed. Retail businesses, banks, and an insurance company developed early in the 19th century, and the town's oldest continuously operating business, the Andover Bookstore, began in 1809 on Andover Hill. Other manufacturing endeavors followed the mills, but they were often small, such as William Poor's Wagon Shop in Frye Village. Andover's business class began to grow, increasing the town's wealth.

Andover had a strong abolitionist movement, led by William Jenkins, Elijah Hussey, and William Poor, who participated in the Underground Railroad, facilitating the escape of Southern slaves to Canada. Earlier, a few Andover families had slaves, but it appears they were treated well, with many receiving their freedom.

Andover's first railroad, opened in 1835, allowing passengers to connect to Boston. The first station was on upper Essex Street where the parking lot for the Memorial Hall Library now exists, and the track ran south from there.

Andover's participation in the Civil War was strong; the town contributed more men than its allotment. Of the participants, 46 died and 3 were awarded the Medal of Honor. Largely financed by local businessmen, Andover built the Memorial Hall Library in 1871 to honor its Civil War veterans.

Soon joining the library were the Carter Block, the Musgrove Building, and then the Barnard Building in 1910. Andover's modern-day downtown took shape. The removal of Andover's landmark Centennial Elm in 1919 to make Elm Square safe for automobile and trolley traffic was symbolic of the direction the town was headed.

The first seeds of conservation were planted when Andover Village Improvement Society (AVIS) held its organizational meeting in 1894, and then a few Andover women raised money to save Indian Ridge from deforestation in 1898.

Almost 500 Andover men volunteered to fight in World War I, and 14 died. The Spanish Flu epidemic of 1918 and 1919 killed 25 residents.

From 1919 to 1923, Frye Village was replaced by the planned community of Shawsheen due to the vision and enterprise of one man, William M. Wood, who owned American Woolen Company.

In search of cheaper labor, most large mills of the Northeast moved south by the early 1960s, causing high unemployment in the area. Andover's center was shabby in the 1950s and 1960s, but developers corrected that, although not always to everyone's architectural preference.

Andover's involvement in World War II was intense, with more than 1,800 men and women in uniform, not including those who joined the Canadian and British Armed Forces before America entered the war. From Okinawa to the heart of Germany, Andover men saw combat and 60 died. The war resulted in shortages and rationing at home, but few complained. The Korean War (1950–1953) cost the lives of four Andover men, and seven more brave Andover men died in the Vietnam War.

The town was affected in the late 1950s and early 1960s by the construction of Interstates 93 and 495, which intersect in Andover. The eminent domain taking of farmland and homes from West Andover through Shawsheen was traumatic. The farms of Andover, a beautiful part of the town deep into the 20th century, began to disappear not just from the building of the highways, but because the commercial value of land near those highways increased in value. Throughout the second half of the 20th century, real estate values increased so much that the financial incentive for selling land was strong. The town adjusted, and several large, premier industries, as well as hotels, moved near the highways. Andover became the economic heart of the region. Its population, which started to grow after World War II, climbed more rapidly as the 20th century drew to a close. Today, Andover is close to fully developed with respect to residential land; because Andover is such a nice place to live, the demand for housing exceeds supply, resulting in high home prices and a leveling off of population growth.

In the 1980s, the municipal offices moved to the old Punchard High School building. At the same time, the Park was upgraded and the old town hall preserved. More recently, the town center received a facelift with new sidewalks and lighting.

The town's beauty, widespread conservation areas, fine public and private schools, excellent athletic teams, good government, excellent police and fire departments, as well as access to Boston, New England's recreation areas, and airports all help make Andover a great place to live.

Andover's population is a little more than 33,000, and it is geographically large, encompassing over 32 square miles. Andover has seven districts and 45 structures in the National Register of Historic Places. Thanks to the master plan of Andover, created decades ago, as well as the work done by all sectors of the community, there are few places in the country that offer such overall excellence. That excellence, to a significant extent, was created by the people in this book.

Several of those named within these pages are unsung, yet made important contributions to Andover. A very few were notorious. It speaks to the greatness of the town that a comprehensive list of people who made important contributions to Andover would far exceed those mentioned in this book.

The seven chapters serve as convenient divisions, although it will be apparent that some people could fit into more than one chapter.

A note to readers: Throughout this book, the name "Andover" refers only to the town. "Phillips Academy" and "PA" refer to the school.

Also, since Andover included North Andover prior to 1855, a few of the people in this book lived in what became North Andover. Ballardvale, Shawsheen, and West Andover are parts of Andover; Shawsheen was called Frye Village before 1919; Abbot Village no longer exists as a geographical place to which people refer, although it existed around the mills near the intersection of Essex Street and Red Spring Road. Marland Village grew up around the Marland Mills, later the Stevens Mills. The structures still exist on Stevens Street, and the name "Marland Village" has recently been reborn. Punchard was the name of Andover's High School prior to September 1957.

CHAPTER ONE

Historians, Authors, and Artists

The story of Andover is so interesting that it attracts historians. This chapter includes some of those historians who not only wrote about Andover but also had intimate connections with the town. Therefore, not included is Eleanor Motley Richardson, who wrote a fine book, *Andover: A Century of Change* (1995). She was employed to write the book, but had no other connection to the town. Also not found here is Philip J. Griven, who wrote the scholarly *Four Generations: Population, Land, and Family in Colonial Andover, Massachusetts* but had no other ties to the town. Along the same lines, Buzz Bissinger, author of *Friday Night Lights* (1988) and the winner of the Pulitzer Prize for investigative reporting, and Julie Alvarez, author of *How the Garcia Girls Lost Their Accents* (1991), are not in this book because their only connection with Andover is that they went to Phillips Academy. Also not included in these pages is Munro Leaf, the author of the children's classic *The Story of Ferdinand* (1936), although he wrote the lesser-known *The Wishing Pool* (1958) when he lived in Andover for two years. The decision not to include Leaf was a close one, and it illustrates the criteria for those that are found in this chapter. In the case of Harriet Beecher Stowe, although she did not write *Uncle Tom's Cabin* in Andover, it was an easy decision to include her in this book, as will become clear later in this chapter.

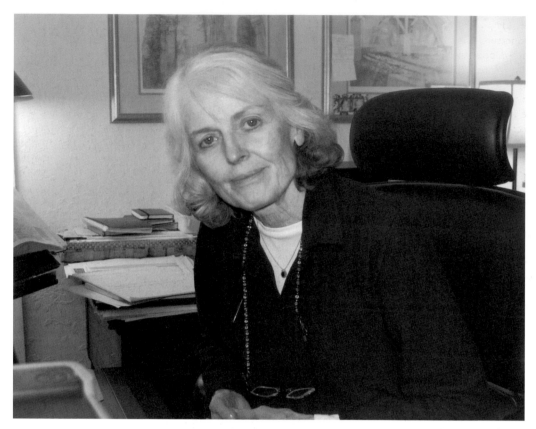

Mary McGarry Morris

For many years, Morris had a secret that only her immediate family knew: she was writing a novel. Because she and her husband, attorney Michael Morris, were raising five children, much of that writing was done at odd hours. But what a first novel she created! In 1988, *Vanished* was published to critical acclaim. It was nominated for the National Book Award, as well as the PEN/Faulkner Award, and it won the Barnes and Noble Discover Great New Writers Award. The book established her as a literary writer of the highest order, but could she do it again? Indeed, she could, over and over. Her second novel, *A Dangerous Woman*, secured her position in the literary world. It was picked by *Time* magazine as one of the five best novels of 1991 and was made into a motion picture starring Debra Winger and Gabriel Byrne. Her third novel, *Songs In Ordinary Time* (1995), was chosen as an Oprah's Book Club selection, sending it to the top of the *New York Times* best-seller list for many weeks. CBS made it into a movie, and the book became an international best seller. Her next four novels received similar praise, and her most recent novel, *Light from a Distant Star* (2011), evoked a comparison with Harper Lee's *To Kill a Mockingbird* in the *Washington Post*. Morris is working on a novel that is expected to be released in 2014. Before she was a writer, Morris, raised in Vermont, was a social worker in Lawrence. She and her husband are longtime residents of Andover. (Courtesy of the Morris family.)

Paul Monette
Monette was an American author, poet, and gay activist who wrote primarily about gay relationships. He knew he was dying of AIDS when he wrote his autobiography, *Becoming a Man: Half a Life Story*, which won the 1992 National Book Award for Nonfiction. Previously, he wrote the critically acclaimed *Borrowed Time, An AIDS Memoir* (1988). He grew up in Andover and went to school at Phillips Academy. (Photograph by Robert Giard, 1988 copyright Estate of Robert Giard, courtesy of Stephen Bulger Gallery.)

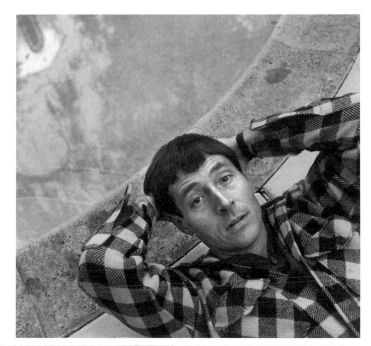

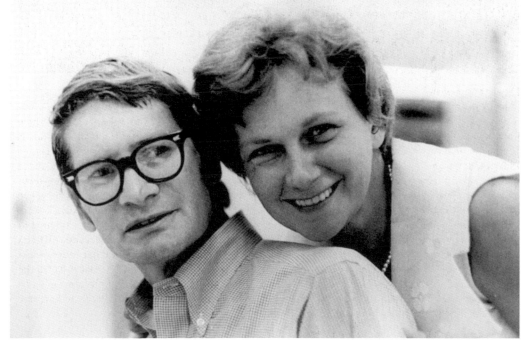

Andrew Coburn
Between 1974 and 2007, Coburn (1932–present) wrote 13 novels. *Goldilocks* (1989) was a nominee for the 1990 Edgar Award. Coburn's exciting and enjoyable books often mention Andover. He writes nonfiction and short stories as well, with 30 of his short stories appearing in literary journals. His works have been translated into 14 languages, and three of his novels were made into French films. His wife, Bernadine Casey Coburn, is a former journalist who teaches writing in a women's jail. (Courtesy of the Coburn family.)

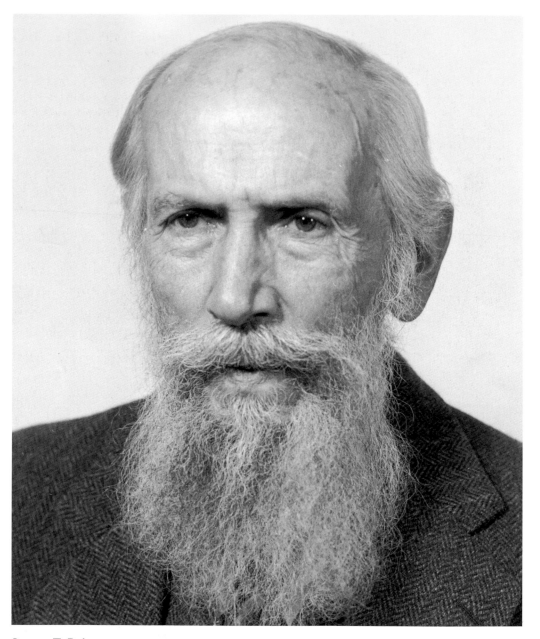

Steven T. Byington

Known as the "Bard of Ballardvale," for 60 years, Byington, a trained minister, translated the *Bible* into modern English, much of that time while commuting by train to his proofreading job in Boston. His beautifully written translation, published posthumously under the title *The Bible in Living English*, sold 100,000 copies in its first year. Always wearing sneakers, regardless of the weather, Byington (1869–1957) was frequently seen walking with a book bag over his shoulder between Ballardvale and the Memorial Hall Library. In church, he would politely correct a minister's misinterpretation of the *Bible* during the service. Publishing articles in various journals, he sent letters to the editor on a wide variety of subjects, and those letters were published all over the country under the signature, "Steven Byington, Ballard Vale, Mass." A beloved man, he was a true intellectual. (Courtesy of AHS.)

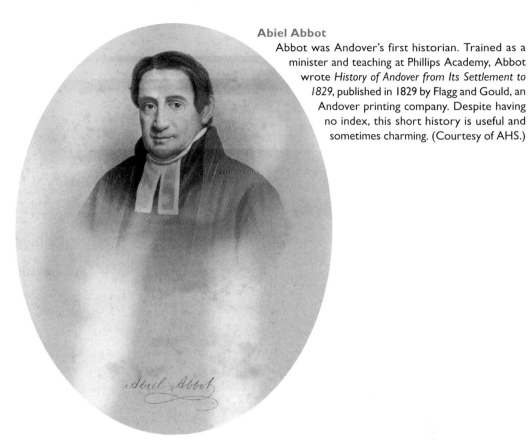

Abiel Abbot

Abbot was Andover's first historian. Trained as a minister and teaching at Phillips Academy, Abbot wrote *History of Andover from Its Settlement to 1829*, published in 1829 by Flagg and Gould, an Andover printing company. Despite having no index, this short history is useful and sometimes charming. (Courtesy of AHS.)

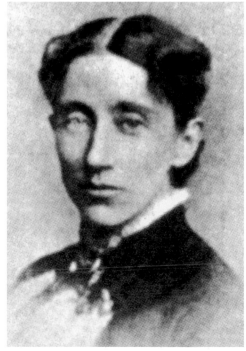

Sarah Loring Bailey

Bailey is Andover's most quoted historian. Her *Historical Sketches of Andover Massachusetts*, published in 1880, began as a collection of short sketches. In the words of Bailey, the book was "intended to capture the romance and poetry of Old Andover." By the time she finished, she had a book of 626 exquisitely researched pages. Her great-grandfather, Samuel Bailey Jr., was killed at the Battle of Bunker Hill while trying to rescue wounded fellow townsmen. (Courtesy of AHS.)

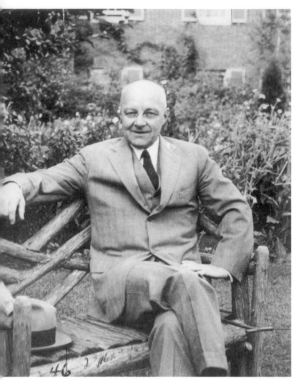

Claude M. Fuess
Fuess wrote *Andover, Symbol of New England* (1959), which discussed Andover's history from before 1646 to 1946. He was a fine, prolific author, and his writings include a widely read biography of Calvin Coolidge, a fellow Amherst College graduate. Fuess (1885–1963) taught English at Phillips Academy for 30 years before serving as its headmaster from 1933 to 1947. He was chairman of the town's tercentennial committee in 1946. (Courtesy of Phillips Academy Special Collections.)

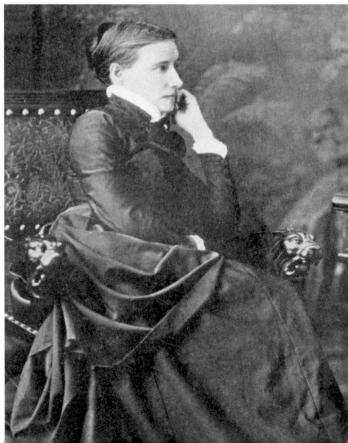

Elizabeth Stuart Phelps
Phelps (1844–1911) was America's second-best-selling author of the 19th century. *The Gates Ajar* (1868) was the second-highest-selling book of that century, and many of Phelps's other books sold very well. Although her earliest fiction may appear dated, her later novels and writings do not. In these, she discussed the conditions of the working poor as well as feminist issues. She was ahead of her time and deserves to be better known today. (Courtesy of AHS.)

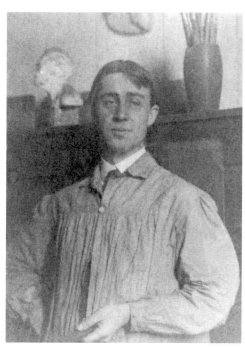

Addison B. LeBoutillier
From 1905 to 1931, LeBoutillier (1872–1951), an architect, artist, and craftsman, lived in Andover and designed two well-known Andover structures and numerous houses. The first of his two significant structures was the 1917 Punchard High School. It now serves as the Andover town office building. The other important building was the Shawsheen School, completed in 1924. It has served the town well for 90 years. (Courtesy of AHS.)

Miriam Sweeney McArdle
Punchard and Andover High's All-Girl Marching Band wore light-blue uniforms. The creator of the band, Miriam Sweeney, painted her 1939 Ford the same color and wore light-blue clothing when the band performed. The band took the field in 1940 with uniforms designed by Sweeney and made by parents. The only all-girl band in the state, it numbered as many as 100 girls. In 1971, it merged with the boys' band. Sweeney was the longtime head of the music department. By 1950, she had married and become Mrs. McArdle. She retired in 1959. The Miriam Sweeney McArdle Award for Musical Excellence is given each year. (Courtesy of AHS.)

Richard Graber

"Moving to Andover from Indiana was like moving to a foreign country. Everything was different here," Richard Graber said. He became Andover's unofficial photographer in 1962, following in the footsteps of Charles Newman, who photographed Andover from 1889 into the 1930s, and Donald Look, who photographed Andover from 1943 to 1954. Graber first worked in a small room in the Musgrove Building, then moved to a studio on Park Street. He was associated with Phillips Academy as its photographer for over two decades. The academy maintains an archive of his images of the school. The town center looked shabby in places when Graber started capturing images of it, providing an opportunity for interesting photographs. Many of his photographs were taken in and around Elm Square, and a collection of them was put together with the help of Howard and Katherine Yezerski, friends of many artists. Graber (1934–2007) worked almost entirely in black and white. Some of his photographs are found in this book. (Self-portrait by Richard Graber, courtesy of Jennifer Graber.)

Charlotte Helen Abbot

Historian Claude Fuess described Abbot as "stately." A teacher, Abbot's hobby was genealogy, but she expanded her interest, becoming a professional genealogist. For 25 years, Abbot (1844–1922) wrote a column for the *Andover Townsman*. Her genealogy work on area families is housed at the Andover Historical Society. (Courtesy of AHS.)

Caroline Underhill

In 1926, the Andover Historical Society was unable to fund the purchase of the Amos Blanchard House, then owned by Underhill (far right). In 1929, she agreed to accept an annual payment of $420 and a life estate, allowing her to live in part of the house. Underhill (1867–1956) became the first curator of the society, serving for 25 years, cataloging its possessions and helping in research. (Courtesy of AHS.)

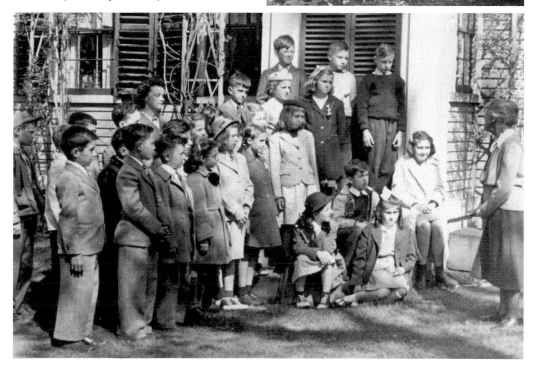

Anne Dudley Bradstreet
Having received a tutored education before leaving England, Bradstreet (1612–1672) was America's first published poet. Her husband, Simon, and her father, Thomas Dudley, were both future governors of the Massachusetts Bay Colony. The Bradstreets arrived in America in 1630 and settled in Andover in 1645; Simon was considered the town's "first citizen." John Woodbridge, who was briefly Andover's first minister, was married to Anne's sister, and he had Bradstreet's poems published in London under the title *The Tenth Muse Lately Sprung up in America* (1650). The poems were well received. In recent decades, recognition of her talent has been reborn. Reading her sometimes beautiful poetry gives one an idea of living in 17th-century frontier New England, albeit from the perspective of a relatively well-off woman. Her grave has never been found, but a commemorative marker was placed in the Old North Andover Cemetery.

Bradstreet's son Dudley was Andover's first town clerk and a representative to the general court. However, during the witch hysteria, he believed it imperative to move his family temporarily out of the area.

A likeness of Anne Bradstreet is seen here in a detail in a window in St. Botolph's Church, Boston, England. (Image reproduced with the kind permission of St. Botolph's Church, Boston, England.)

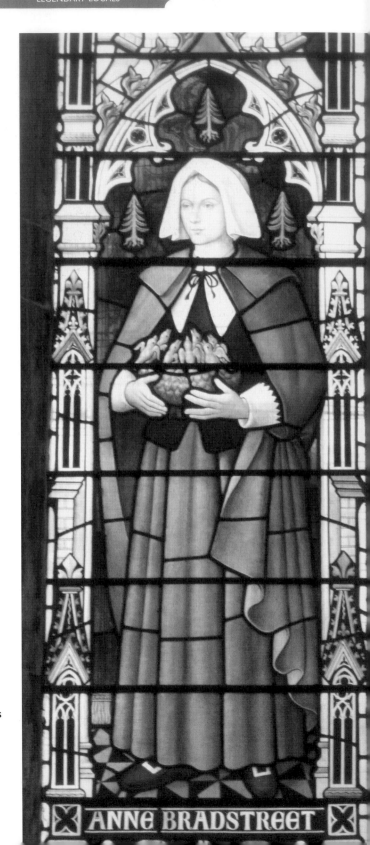

ANNE BRADSTREET

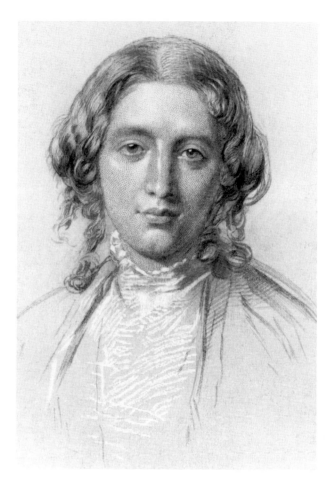

Harriet Beecher Stowe

Uncle Tom's Cabin had just finished its run as a serial in an abolitionist newspaper and was being published as a book when Harriet Beecher Stowe's husband, Rev. Calvin Stowe, accepted a professorship at Andover Theological Seminary in 1852. The couple purchased a stone storage building and converted it into a house they called the "stone cabin," which now sits at the top of Bartlett Street. The Stowes lived there for 12 years with their children. Harriet (1811–1896) reached the peak of her career in Andover, writing several books, magazine, and newspaper articles, including columns in Andover's weekly paper, the *Andover Advertiser*, that later became a book. She went on numerous speaking tours, meeting Queen Victoria and President Lincoln, who thoroughly charmed her. The theological seminary's strict religious philosophy and Stowe did not always agree. Behavior that would not have been tolerated in other faculty wives was mostly overlooked. Stowe had numerous parties and put up what may have been the town's first Christmas tree, considered a pagan symbol by many contemporary theologians. She even allowed her oldest children, twin girls, to give a party for their Abbot Academy friends. Some on the seminary faculty criticized the Stowes, but the couple apparently ignored it.

Life was not all gaiety for the family. In 1849, before moving to Andover, they lost an 18-month-old boy to cholera. In addition, there is the story of the strange disappearance of their son Frederick. Wounded in the head while fighting for the Union in the Civil War, he returned home and was never the same; he was emotionally and perhaps cognitively impaired. Frederick became an alcoholic, and his mother blamed it on his wound. He moved to San Francisco and disappeared, never to be heard from again. Harriet Beecher Stowe is interred alongside her husband in the Old Burial Ground at Phillips Academy. (Courtesy of AHS.)

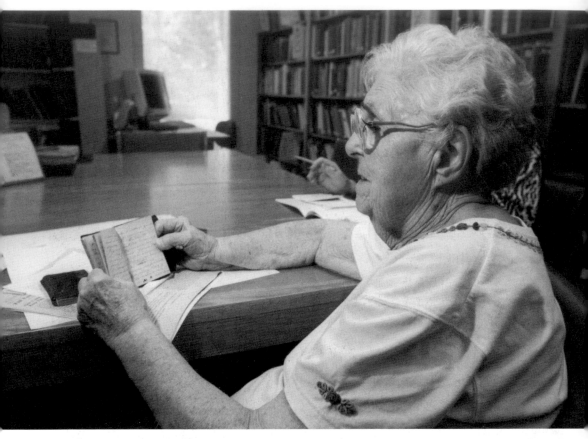

Ruth Davis Sharpe

In 2004, the Ballardvale Historic District Commission created the Ruth Davis Sharpe Preservation Award. At the time, the commission gave the following statement: "The Annual Award shall be named to honor the late Ruth Davis Sharpe, a lifelong resident of Ballardvale who, if the buildings and other physical aspects of 'The Vale' represent its body, then she was the very soul of this special place, having been for most of her life the custodian of its history and its quintessential advocate for its preservation as a vital, living and exciting part of the town of Andover." Posthumously, Sharpe was the first to receive the award. Both of her parents worked in the Ballardvale Mills on the Shawsheen River, and she spent much of her life keeping alive Ballardvale history. Sharpe (1911–2003) was the last librarian at the Ballardvale Branch of Memorial Hall Library, a position she held for 22 years. Upon her retirement in 1991, she was presented with the Ballardvale Honored Citizen Award by the Ballardvale Village Improvement Society. She served on the Ballardvale Historic District Study Committee that, after more than three years of hard work, led to Ballardvale being designated a historic district. For almost 30 years, until days before her death, Sharpe was an active volunteer with the Andover Historical Society and contributed to its newsletter. For many years, she and her husband, Ralph, appeared as Mr. and Mrs. Santa Claus at local Christmas activities. (Courtesy of AHS.)

Juliet Haines Mofford
Having worked at the Andover Historical Society for several years, a favorite subject of Mofford's is the town's history. Her *Andover Massachusetts Historical Selections from Four Centuries* is a must-read for anyone interested in Andover's history. An earlier book, *A History In Conservation: The Andover Village Improvement Society, 1894–1975*, won a national award. Working with Andover storyteller and actress Susan Lenoe, Mofford created community programs about historic Andover women; both Lenoe and Mofford received historic preservation awards. For Andover's 350th anniversary, in 1996, Mofford wrote a play about the town's 19th-century best-selling author Elizabeth Stuart Phelps, and Mofford's daughter Lauren portrayed Phelps in this one-woman show. As of the writing of this book, Mofford's most recent publications are *The Devil Made Me Do It*, a book about crime and punishment in early New England that mentions several Andover people, and *Abigail Accused—A Story of the Salem Witch Hunt*, a book about Andover's heroic Abigail Dane Faulkner, who was once convicted as a witch. (Courtesy of AHS.)

Joan Silva Patrakis

Before writing *Andover in the Civil War* (2008), Patrakis received the Andover Historic Preservation Commission's Individual Achievement Award. In the past 35 years, she has written more than 100 articles for the Andover Historical Society's Newsletter and local newspapers. Patrakis received her bachelor of arts degree at the age of 59 from Lesley College. While there, she helped create and was director of the women's center at Northern Essex Community College, heading up the Women Returning to School program. (Courtesy of AHS.)

Bernice M. Haggerty

Haggerty was the cheerleader captain the year she graduated from Punchard (1940). She has been a longtime Ballardvale resident and historian, serving on the Ballardvale Local Historic District Study Committee and other community groups. She served two terms as a director of the Andover Historical Society. During the town's 350th anniversary, Haggerty was on the book committee for *Andover A Century of Change* as well as on the rededication committee for the Andover Town House. A daughter says that her mother loves Andover but bleeds Ballardvale. (Courtesy of the Haggerty family.)

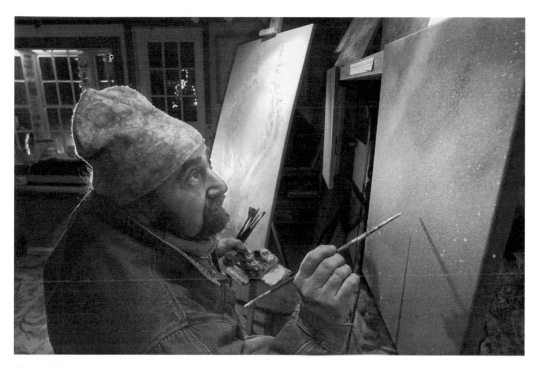

Corey Tevan

Tevan has always thought of himself as an artist. Taking private lessons from Frances Dalton throughout his youth, he graduated from Andover High in 1966. His art is found in private, public, and corporate collections worldwide. He is represented by the Howard Yezerski Gallery and has been collected by the Addison, the Museum of Fine Arts, and many other art museums. Tevan taught at the School of the Museum of Fine Arts, Boston and the Brooks School. He has a year-round gallery in Rockport, Massachusetts. (Courtesy of Corey Tevan.)

Frances L. Dalton

After attending Punchard, Dalton (1904–1989) received scholarships to the School of the Museum of Fine Arts, Boston, and the Sorbonne. She returned to Andover after four years in Europe, painted numerous portraits, and became head of the art department for Andover Schools. Her teaching style was unconventional, allowing students to find their natural talent, but it succeeded, as her students always took home the most statewide prizes. She believed that a "stilted, programmed art curriculum can never meet students squarely nor follow them down the unexpected paths they pursue." The Andover Historical Society exhibited a retrospective of her work at the Andover Town House's reopening. (Courtesy of James Batchelder.)

Samuel Francis Smith
While attending Andover Theological Seminary in 1831, Smith wrote the lyrics to the patriotic song "America" ("My Country, 'Tis of Thee") in what is now the America House, at 147 Main Street. Smith (1808–1895) wrote more than 150 hymns and coauthored *The Psalmist*, a Baptist Church hymnal. (Courtesy of Phillips Academy Special Collections.)

William Harnden Foster
Purina annually gives a national award named after Foster (1886–1942). He went to the School of the Museum of Fine Arts, Boston, and illustrated the first cover of the L.L. Bean catalog, in 1925. Along with two other Andover men, Charles Davies and his son H.W. Davies, Foster invented skeet shooting in 1910. In 1926, he brought the sport to national attention while editor of the *National Sportsman* magazine. A book written and illustrated by Foster, *New England Grouse Shooting* (1942), is the classic of its genre. (Courtesy of the authors.)

CHAPTER TWO

Merchants and Mills

In the 19th century, Andover's agrarian economy expanded to a more mixed economy. Andover's entrepreneurs took root, and the business class grew, increasing the town's wealth. By the end of the 19th century, Andover, Ballardvale, Frye Village, and Abbot Village all had mills and retail businesses. Andover's center looked a bit like it looks today. Ballardvale had a picture-book center with a few retail stores and a beautiful mill building with a millpond in front of it. Frye Village was a place for small to midsized manufacturing plants, with little retail. If one went back in time to the village in 1900, very little would be recognized. Frye Village was probably named for Samuel Frye, who once owned a sawmill on the Shawsheen River. Abbot Village was named for Abel and Paschal Abbot, who built a small textile mill in 1814. It addition to company stores, Abbot Village had a store or two located at the bottom of Essex Street, where it meets Red Spring Road. Farquhar MacKenzie owned a butcher shop on the west side of Red Spring Road. He was from Brechin, Scotland, as were the owners of the Smith & Dove Company and many of its employees. Although some of the commercial structures that made up Abbot Village still exist, including the Abbot's original mill, only a few people remain who have memories of Abbot Village as a place.

The people highlighted in this chapter will help the reader understand how Andover developed commercially over the last two centuries.

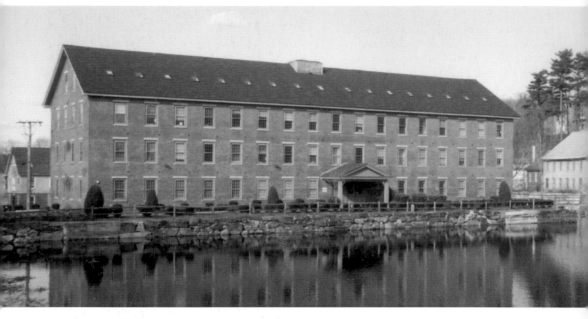

Timothy Ballard and Capt. Josiah Putnam Bradlee
In the late 18th century, Timothy Ballard built a mill (shown here) on the Shawsheen River in Ballardvale. Although Ballardvale may have been named for him, it is possible that it was named for Joseph and John Ballard, who were among the first people to settle in the South Parish (Andover), more than 100 years before the establishment of Timothy Ballard's mill. In 1836, Ballard sold the property to a group led by John Marland, who formed the Ballardvale Manufacturing Company and more fully developed the mill. When the company failed in 1857, Captain Bradlee (also known as J. Putnam Bradlee), treasurer of the company since 1842, purchased it. By 1866, he paid off all its debts and renamed it Bradlee Mills. Bradlee (d. 1887), who lived in Boston, was an early believer in good labor relations; he gave workers products at cost, provided low-cost housing, established the Ballardvale library from his own collection of books, provided lectures and concerts, and created a pension system. Although he owned the John Marland House on Andover Street, he never lived there, instead using it as a place for business guests. It has often been said that Ballardvale was the part of town that had the most fun; perhaps it was due to Bradlee keeping his employees happy. At the company's peak, 250 workers produced worsteds and high-quality flannel. The Bradlee School, now condominiums, was named for him. (Courtesy of AHS.)

John H. Campion (1860–1932)

John Campion rebuilt the Carter Block, at the junction of Main, Essex, and Central Streets, after it burned down in 1882. He erected a large produce outlet, J.H. Campion Market, facing Elm Square. The business ran successfully for 40 years. His daughter, Gertrude Campion (Soutar), inherited the building when she was 22 years old. She owned it until 1969, selling it to Macartney's clothing store. Pictured at right are John Henry (left), Gertrude (center, age 103 at the time of this writing), and Mrs. Henry Campion. (Courtesy of Ms. Jane Soutar.)

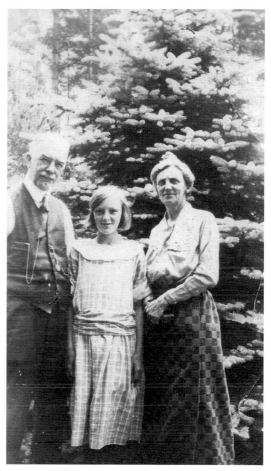

Jacob Barnard

When young Jacob Barnard delivered blueberries to Benjamin Punchard at the now-historic house on the corner of Main, Elm, and High Streets, he said to Punchard, "One day, I'm going to own this house." And he did. Barnard grew his one-man shoe business into a 200-employee company, located in the brick building he erected in 1883 at Barnard and Main Streets. His son Henry built the Barnard Block on Main and Park Streets in 1910, pictured here. (Courtesy of the authors.)

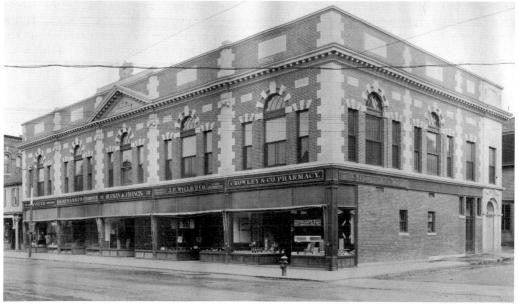

29

Burton S. Flagg

Flagg was one of Andover's most important people of the 20th century. He was the longtime president and treasurer of the Andover Companies, president of Smart & Flagg Insurance Agency, president of the Andover Savings Bank for 30 years, director of the Andover National Bank, treasurer of Abbot Academy for 40 years, and trustee of the Memorial Hall Library for 35 years. Burton Flagg (1873–1973) served on the town's school committee, finance committee, tercentennial committee, and very much more. He was a dignified, straight-forward man with high standards. He left a lasting impact on Andover. (Courtesy of AHS.)

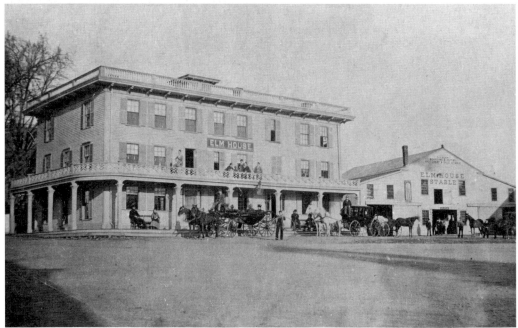

Samuel G. Bean

"Uncle Sam," as Bean was known to townspeople, owned the Elm House, a tavern and inn with adjacent boarding and livery stables. The Elm House faced Memorial Hall Library, with converging roads and a small village green between them. Bean, a colorful man, drove his four-horse stagecoach while wearing a white beaver hat and duster. In 1894, the Elm House was replaced by the Musgrove Building. (Courtesy of AHS.)

Samuel Farrar

Farrar was so respected and important to Andover that he was known simply as "Squire" or "The Squire." Before age 30, Farrar was a trustee of Phillips Academy, soon becoming its treasurer. He was a founding sponsor of the Andover Theological Seminary in 1808 and a founding trustee of Abbot Female Seminary in 1829, becoming treasurer of both institutions. Farrar (1773–1864) was a founder and the first president of the Andover National Bank, serving from 1826 to 1856. Few people in Andover were ever so beloved. (Courtesy of AHS.)

Amos Blanchard

The Andover Historical Society is located in the Amos Blanchard House. Blanchard (b. 1773) worked for Squire Farrar in two jobs, first as a clerk when Farrar was treasurer of Phillips Academy, then as cashier and secretary of the board of directors of the Andover Bank when Farrar was president. Blanchard served on the first board of directors of the Merrimack Mutual Fire Insurance Company, formed in 1828. (Courtesy of AHS.)

31

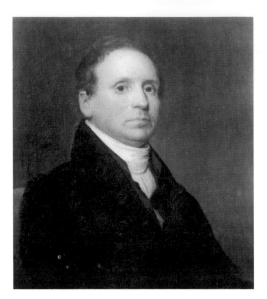

Mark Newman
Newman was the principal of Phillips Academy from 1794 to 1810, a period of decline for the school. However, in 1808, Andover Theological Seminary opened next to the academy, and Newman established a bookstore to provide textbooks, primarily to the seminary. The shop became the Andover Bookstore. In 1828, Newman became one of the founding trustees of Abbot Female Seminary, which became Abbot Academy. Newman generously donated the land for the school. (Courtesy of Phillips Academy Special Collections.)

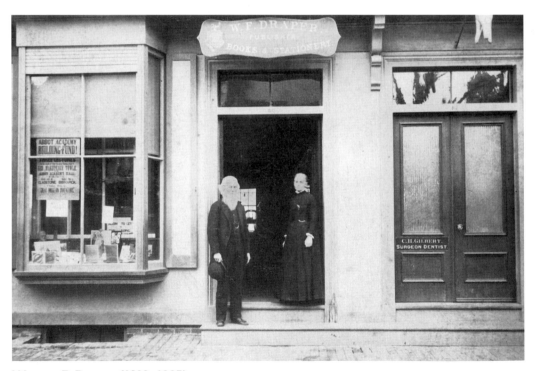

Warren F. Draper (1818–1905)
Draper was a fine example of the rise of the merchant class in Andover. After working in a printing company above Mark Newman's bookstore, Draper bought the company in 1834 and turned it into the Andover Press, a nationally known publisher. For 15 years he owned the *Andover Advertiser*, the town's first newspaper, as well as a retail book and stationery store. Apparently, he took over the bookstore that Mark Newman started. Draper donated $100,000 to Andover institutions. In 1887, after the close of the *Andover Advertiser*, Draper sold his holdings to a corporation controlled by John N. Cole. (Image courtesy of AHS.)

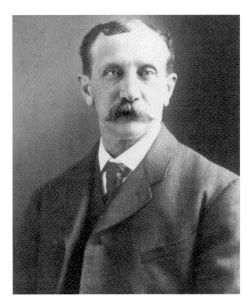

John N. Cole (1863–1922)

Cole was Andover's most important person just after the turn of the 20th century. From its inception in 1887 until his death, he was the dominant figure at the *Andover Townsman*, serving as both editor and publisher. Cole was speaker of the Massachusetts House in 1906, 1907, and 1908. In 1916, he was appointed to the state committee on waterways, and in 1919 his friend Governor Calvin Coolidge appointed him as commissioner of public works. He built the Arco building on the east side of Main Street and owned the Press building, on the corner of Main and Chestnut Streets, which housed the *Townsman* as well as Cole's other two businesses, the Andover Bookstore and the Andover Press. Cole was active at town meetings and did not hesitate to support his views in editorials. Opinionated but not mean-spirited, he was both a newsmaker and news writer. Note at the bottom left of the Andover Press Building image Is the sign for Playdon Floral Designs, an award-winning and popular florist in town for many years. (Images courtesy of AHS.)

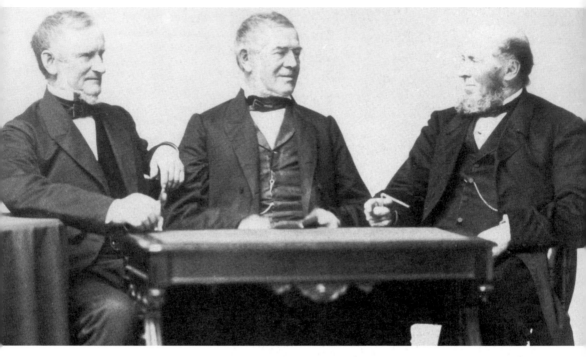

John Smith, Peter D. Smith, and John Dove (from left to right)
Many Scots in Andover are related to people who emigrated from the area in and around Brechin, Scotland, and came to Andover to work in the Smith & Dove Company, whose three owners were from Brechin. John Smith (1796–1886) came to America in 1816. In 1824, with two partners, he constructed a mill in Frye Village. By 1831, he was sole owner, and he soon brought his brother Peter Smith (1802–1880) and their friend John Dove (1805–1876) into the business as employees. However, when John Smith built a large flax mill in 1836, he did so under the name Smith & Dove, having given his brother and Dove partnerships. It was the first flax mill in the country. In 1843, the firm was doing so well that it moved to a larger mill the three men constructed in Abbot Village, off lower Essex Street and Red Spring Road. The owners also bought the 1814 building erected by Abel and Paschal Abbot, who gave the village its name. In 1846, John Smith, an abolitionist, became a founder of Free Church. In 1865, the company started constructing additional brick structures near the mill, including dormitories and recreation buildings. At a later date, the company built playing fields, known as the Cricket Field. Abbot Village grew rapidly. The Smiths and Dove became philanthropists. The Memorial Hall Library was largely financed by them, and they gave generously to Andover's private schools.

Smith & Dove employed more than 300 people at the end of the century and closed in the late 1920s. Many of the buildings still remain off Essex Street below the tracks, and on Red Spring Road. The Cricket Field, near St. Augustine's Cemetery, was active into the 1950s, used mostly by teenagers playing baseball. (Courtesy of AHS.)

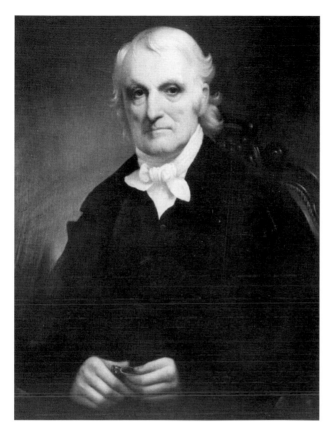

Abraham Marland
An emigrant from England in 1801, Marland, by 1807, owned an Abbot Village cotton mill. Soon after, he bought what had once been a Revolutionary War powder mill, located across from the present-day post office. There, he produced wool to provide blankets during the War of 1812. He later increased the size of the mill, running it until his death in 1849. In 1879, Moses T. Stevens, for whom Stevens Street is named, bought Marland Manufacturing. Marland was instrumental in founding what became Christ Church. (Courtesy of Christ Church and AHS.)

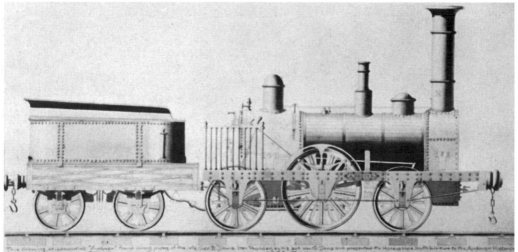

Hobart Clarke
Entrepreneur Hobart Clarke created Andover's first railway. On June 6, 1835, the Andover & Wilmington Railway opened, and the first train arrived in Andover to a huge, cheering crowd. The train station on upper Essex Street later became the Andover Playhouse, then was used to house town offices. The structure was finally torn down to make room for library parking. Nathaniel Whittier, for whom Whittier Street is named, was the first superintendent of the railway. (Courtesy of Bernice Haggerty.)

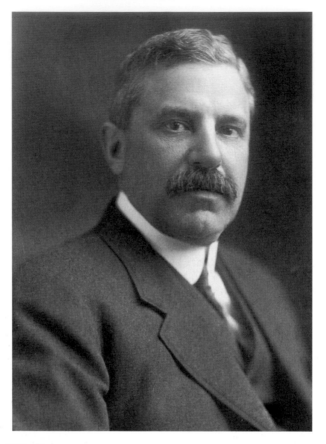

William Madison Wood

Wood (1858–1926) was one of the country's great business geniuses of the early 20th century. From his first business, selling apples on the streets of New Bedford to support his widowed mother and siblings, he became the leader of an industry. While selling apples, Wood caught the attention of a mill owner, who offered Wood a job. Wood's business acumen grew, and a few years later, Frederick Ayer, a Lawrence textile magnate whose largest mill was failing, asked 27-year-old Wood to save it. Wood succeeded and, in the process, married Ayer's daughter. He purchased the John Dove estate on North Main Street in Andover, naming it Arden. In 1905, the Wood Mill, the largest wool mill in the world, was built in Lawrence. That same year, Wood became president of American Woolen Company. His biggest business challenge occurred when the state required mill owners to reduce working hours, and Wood and the other mill owners proportionately cut wages. It was the beginning of the "Bread and Roses strike." Wood became labor's enemy, but, in the end, he agreed to concessions. Influenced by his son William M. Wood Jr., Wood Sr. became a more enlightened employer, and relations with his workers improved. At its height, Wood's company employed 40,000 people in more than 60 mills.

In Andover, Wood undertook a visionary project, the creation of Shawsheen Village from Frye Village. Before construction started in 1919, however, tragedy struck. One of Wood's daughters died in 1918 during the Spanish flu pandemic. In 1922, when construction of Shawsheen Village was near completion, William M. Wood Jr., Wood's chief advisor and heir apparent, lost control of his car and died. By this time, the one-million-square-foot Shawsheen Mills was open, and the headquarters for American Woolen Company, the largest woolen company in the world, moved into a new building, which is now Balmoral Condominiums. The deaths of two of his children and a stroke caused Wood to lose interest in business, sell out, and retire. In February 1926, Wood stepped away from his chauffeured car in Florida and killed himself with a .38 revolver. (Courtesy of AHS.)

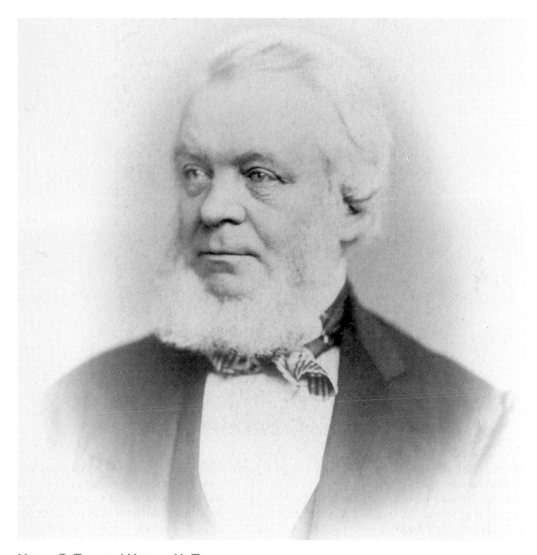

Henry G. Tyer and Horace H. Tyer
When, in 1855, Henry Tyer (1812–1880) opened a small business in Ballardvale, no one could have imagined that Tyer Rubber would one day be Andover's biggest employer. Henry (shown here) was an English immigrant who learned to work with rubber goods. He soon moved the business to Main Street, near Pearson Street, into a building that was subsequently expanded several times. Upon his death, his son, Horace Tyer (1844–1907), took over the company. By 1886, it had 150 employees producing hot-water bottles, nipples, bulbs, and tips for canes and crutches, all marketed under the nationally known trademark "Tyrian." By 1906, the company added football bladders, overshoes, and rubbers. It employed 500 people. Tyer Rubber built a second, larger plant on Railroad Avenue in 1912 to meet the demand for automobile tires. In World War I, it manufactured gas masks, but it was World War II and the Korean War that determined a major expansion in manufacturing for the company. It employed 1,100 people making footwear and raincoats for soldiers and rubber parts for equipment. In 1961, the business was purchased by Converse Rubber, and the Main Street building was torn down in two phases, in 1963 and 1967. In the 1970s, the manufacturing division was moved out of town. In 1980, the Railroad Avenue building was sold to the Corcoran Company, which converted it to low- and moderate-income housing. (Courtesy of AHS.)

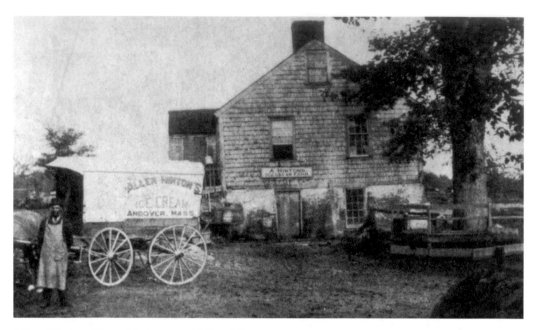

Allen Hinton, Mary Hinton, and Alice Hinton

In 1864, Allen Hinton (bottom left), a former slave freed during the Civil War, came to Andover. He and his wife, Mary, made a living by taking in laundry, waiting tables, and selling snacks to Phillips Academy students, eventually adding ice cream made by Mary. The ice cream was such a hit, the Hintons went into business, first selling from a wagon and then, in 1897, opening an ice-cream store at their farmhouse on Hidden Road (top). They thrived and expanded. When Hinton died in 1912, the business was taken over by his children, notably Alice (bottom right), who maintained it so successfully that she was invited to speak at Booker T. Washington's National Negro Business League meeting in 1915. (All, courtesy of AHS.)

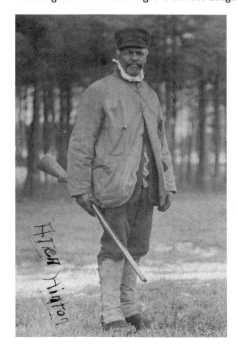

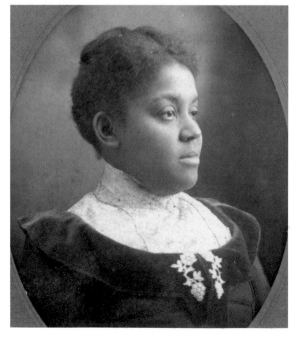

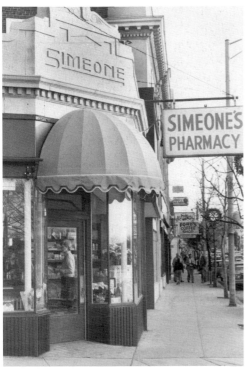

William F. Simeone (1907–1989) and Charles F. Dalton (1899–1983)

Simeone's Pharmacy (left) and Dalton's Pharmacy (below) were two of the three drugstores in the center of Andover for much of the 20th century. Hartigan's Pharmacy was the third. Bill Simeone opened his gleaming pharmacy in the new Simeone Block in 1933, with a soda fountain and a full supply of pharmaceuticals. William "Buddy" Simeone Jr. worked with his father from when he was in high school in the late 1950s until he took over the operation in 1985, changing the name to Andover Medical Supply in order to meet the town's need for medical equipment. The business was sold in 1995.

Charles Dalton purchased Lowe's Pharmacy on the corner of Main and Park Streets in 1936. He had worked in the store since high school. With a large soda fountain and booths, for many years it was a place where Punchard High students congregated. Dalton purchased the Barnard Block in 1958 and sold the pharmacy in 1967. In the below photograph, Dalton (left) is seen with Gov. John A. Volpe at Dalton's Pharmacy. (Left, courtesy of the Simeone family; below, courtesy of the authors.)

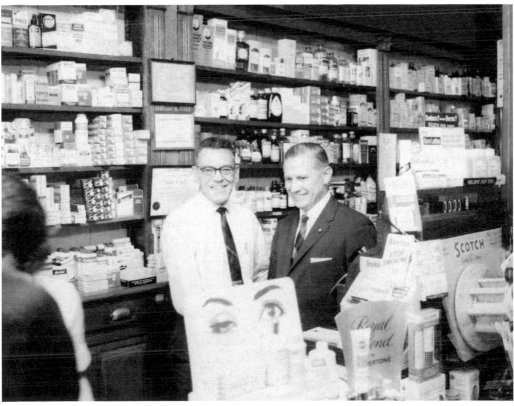

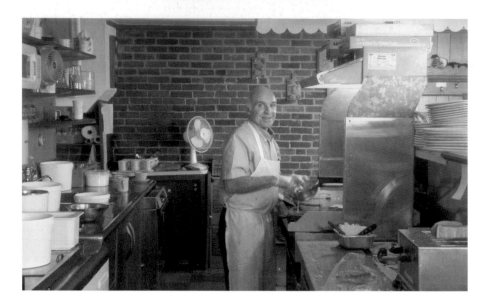

George Dukas; Amy and Bryan Guay

The Lantern Brunch stands at 89 Main Street, next to the Andover Bookstore. The Shawsheen Luncheonette is located in Shawsheen's center on Lowell Street. Both establishments have much in common, including being successfully managed by hard-working owner-operators. Dukas and the Guays are at their businesses when their customers are. Dukas (above) has been standing over the Lantern Brunch grill since 1976, and many of his customers have been eating there for decades. The Shawsheen Luncheonette has many regulars as well—a few have their names on the counter stools. It has been in business since 1956, and the Guays have been there for 25 years. Bryan does the cooking and Amy (below) helps all over, keeping things moving. Both places offer good food and friendly service. (Both, courtesy of the authors.)

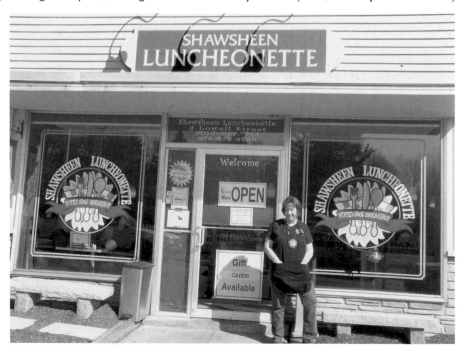

CHAPTER THREE

Educators, Coaches, and Athletes

Andover began its commitment to education in 1700, when it built its first grammar school. In 1856, the town's first public secondary school opened. Today, Andover has six elementary schools, two middle schools, and a high school.

The Playstead was built in 1911, serving as the athletic fields for Punchard High School. The school's first legendary coach started the same year. Manufacturing companies sponsored teams as well. Today, athletics are an important part of Andover. A sports reporter and columnist for the *Eagle-Tribune* and *Andover Townsman*, Bill Burt, wrote, "Andover is a town that eats, sleeps, and drinks youth and high school sports."

This compilation of educators, coaches, and athletes is partial, and many notables are absent. Three Phillips Academy graduates not featured in the following pages are briefly mentioned here. Frank Hinkey (PA 1891) was the most celebrated football player in PA's history and an All-American at Yale for four years. He was called the greatest football player of all time by Pop Warner. William Clarence Mathews (PA 1901), an African American, was a baseball great at Phillips Academy and Harvard. The Ivy League baseball championship is named for him. He eventually became assistant attorney general of the United States, appointed by President Coolidge. NFL coaching great Bill Belichick (PA 1971) played on an 8-0 football team and a 13-1 lacrosse team. He coaches the New England Patriots.

Peter Arthur, who was a young man when he died in 2006, must not be forgotten as an outstanding teacher and coach. A Boston newspaper columnist wrote that Arthur was on a fast track to stardom in the coaching world. An *Andover Townsman* columnist observed that there is a confluence of natural skills and acquired attributes that creates such people as Arthur. He will not soon be forgotten, for his students and athletes loved him.

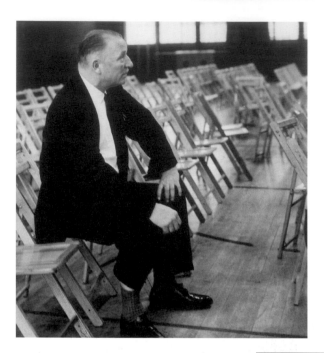

Donald Dunn

Dunn was in the front row for one of the world's most historic events. In World War II, he commanded the ship that was used by top tactical brass to oversee the D-Day landings. In 1959, athletic director Dunn brought Andover sports into the modern era by finding and recruiting Dick Collins and Wil Hixon as coaches. Dunn believed that Andover's youth would best be served with discipline and quality coaching. The high school gymnasium is named for him. From 1950 to 1966, he ran the Guild, a youth sports center, on Brook Street. (Photograph by Richard Graber, courtesy of Jennifer Graber.)

James R. Hurley

As Andover's athletic director from 1987 to 2003, Hurley lived by the credo, "win like a champion, lose like a champion." Graduating from Andover High in 1966, Hurley returned after college to teach physical education. Of the 50 teams he coached in junior high football, basketball, and track, 10 were undefeated and 12 lost only one game. Hurley was the Eastern Massachusetts Athletic Director of the Year in 1997, was awarded the *Boston Globe* Dalton Award (best overall athletic program) twice, and, for 16 consecutive years, was in the top 10 vote-getters for the award. (Courtesy of the Hurley family.)

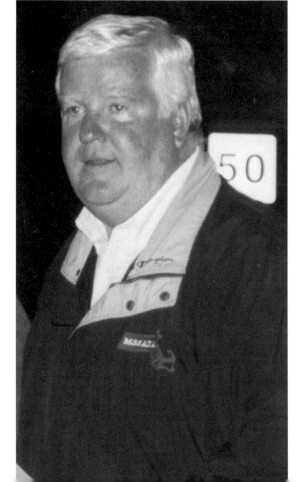

Richard J. Bourdelais

One of the best athletes of his generation, Bourdelais (far left) was among the best coaches of the next generation. He graduated from Andover High in 1961 after being football co-captain and MVP, making the state all-scholastic football team, being state high-jump champion, and winning the Andover Boosters Club Outstanding Athlete Award. Bourdelais attended the University of Massachusetts on a football scholarship. He taught and coached in the Andover Schools from 1968 to 2001, serving as athletic director for five years and physical education director for four. As the indoor track coach from 1968 to 1980, he had seven undefeated dual-meet seasons, winning seven league championships and two state titles. From 1968 to 1984, he was assistant football and track coach. Bourdelais's numerous honors include the 1977 *Boston Globe* Indoor Track Coach of the Year, the 1982 state football coaches association's Assistant Coach of the Year, and membership in the Punchard-Andover Athletic Hall of Fame. The class of 1980 dedicated its yearbook to him, and, in 2001, he received Andover's Unsung Hero Award. (Courtesy of the Bourdelais family.)

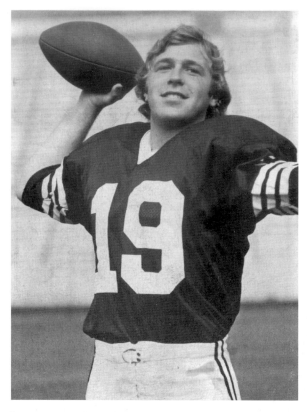

Scott Seero, Dana Seero, and Edward Seero

Scott Seero (AHS '73, pictured here) was one of the rare athletes to be all-conference in three sports: football, hockey, and track. He was first-team quarterback on the all-state football team, leading the state in a nine-game season in touchdown passes (19), total yardage (1,921), and punting average (40.7). In his junior and senior years, the football teams were co-champions of the Merrimack Valley Conference. Seero was one of two Massachusetts football players to make honorable mention on the high school All-American team. He was captain of football and co-MVP with Bob Farnham. That football team started Andover's 40-game regular season undefeated streak by winning its last eight games. He was captain of the hockey team and co-MVP with Dave Hubbell and Bob Farnham. He led the hockey team in scoring and scored three goals in overtime against future Olympic gold medal goalie Jim Craig, sending Andover to the Boston Garden for the first time in the sport of hockey. Picked as the *Eagle-Tribune*'s co-athlete of the year, Scott Seero was offered football and hockey scholarships to college, and he accepted a football scholarship to the University of New Hampshire, where he was starting punter for four years. In 1976, he made the All-East football team, and his UNH punting records were not broken until 2008. He is a member of the Punchard-Andover Hall of Fame, and he coached varsity hockey with Mike Murnane for four years.

Scott's brother, Dana Seero (PA '71), was a high school All-American lacrosse player at Phillips Academy. He was the only two-way starter on an undefeated football team that won the New England prep school championship in 1970. Dana was a tackle in the offensive line that included Bill Belichick as center. At Princeton, he started lacrosse for three years. In the Army, he enlisted as an infantryman and was honorably discharged as an officer with the Army Rangers. Another brother, Edward Seero (AHS '65), was a three-year starter at Andover High School, playing center, offensive tackle, and defensive tackle. He was co-captain with Jim Brent and was selected for the Greater Lawrence All-Stars. Ed received a football scholarship from AIC, where he was co-captain of football and made honorable mention for the small college All–New England team. He served in Vietnam and left the Marines with a rank of captain. (Courtesy of the Seero family.)

Glenn Verrette

Verrette (far left) was a rare three-sport captain, and is among Andover High School's all-time best athletes. He played in Andover's three consecutive super bowls (1973–1975). The team won the last two. The team's overall record was 30-1-1 in the three years Verrette played, with the only loss coming in the first super bowl. He was named to the *Globe* and the *Herald* All-Scholastic football teams for two years as wide receiver and safety. Verrette started two years in basketball and was a co-captain. He was a co-captain and three-year starter in baseball, throwing a no-hitter with 14 strikeouts in one game. His co-captain was his close friend Peter Aumais, who died in a car accident five months after graduating. Verrette often thinks about Peter, to whom the varsity baseball field is dedicated. Winning a full scholarship to play football at Holy Cross, Verrette started at safety and punt returner for four years and was a co-captain his senior year. Verrette's freshman season was very special, because his blind brother was a senior at Holy Cross. In the publicity release about the football team's upcoming senior year for Verrette, he was said to be the best all-around athlete on the squad. He was first team All-East and All–New England. He was fifth in the nation in interceptions, and won the O'Melia Award, given to the outstanding player in the Holy Cross/Boston College game, where he made 18 tackles, 2 interceptions, and knocked down what would have been a game-winning play for BC. Verrette was the ECAC player of the week and the New England player of the week. The players and coaches voted him the top defensive back on the team two years in a row. In baseball, he was a three-year starter and hit three home runs in one game against Brown. He is a member of both the Punchard-Andover and Holy Cross Halls of Fame. Verrette has always lived in Andover, and Verrette's Restaurant, which was in the Musgrove Building in the 1940s and 1950s, was owned by his parents. (Courtesy of Glenn Verrette.)

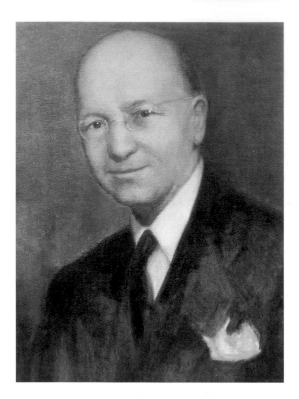

Eugene V. Lovely
He was held in awe by many families, and the high school varsity football field is named for him. Legendary coach "Pop" Lovely (1888–1962) spent all his working life as a coach, teacher, and principal at Punchard High School, and he positively affected thousands of Andover people, acting as a mentor to many. Teaching and coaching from 1911 into the 1940s, he was principal from 1940 to 1950. During World War II, his son was missing in action for three years only to be found alive in a German prison camp. Lovely had several undefeated football teams, including two in a row in 1917 and 1918. Perhaps no person in Andover had a more positive effect on the town's boys. (Portrait by Frances Dalton.)

Charles O. McCullom
Although plenty of men and women worked for youth sports, only a few worked as hard as McCullom in the 1940s and 1950s. He was awarded a plaque naming him "Mr. Basketball" for starting up the church basketball league. He was the first commissioner of the Andover Little League, and he was an important part of the Andover Booster's Club, which purchased uniforms for the Punchard football team and All-Girl Band in the late 1940s. The club squeezed a Little League field into the northwest corner of the Playstead in 1951. Pictured here are, from left to right, Bill, Charles, Tom, and Charlie McCullom. (Courtesy of the McCullom family.)

Joseph Iarrobino

For an Andover resident with a son who played or plays sports, there is a good chance that Iarrobino coached or had some influence on him. Among other things, he has coached American Legion baseball for 26 years; started a youth traveling basketball league; been a varsity assistant football coach; was the vice president of Little League for 22 years; and was the clock operator at the high school basketball games for 20 years. Iarrobino says, "I love Andover and all the great young men I have had the pleasure of coaching." His son, Joe, was a captain and MVP on the 1991 Andover High baseball state championship team and has one of the highest overall batting averages in the history of Rollins College. (Courtesy of Mark Spencer.)

Peter Comeau

A star track and football athlete at Andover High, Comeau is now in the pantheon of its great coaches. Primarily a hurdler as a student, he was a New England champion in 1984, making the 1983 and 1984 *Globe* and *Herald* All-Scholastic teams. He took over as coach of indoor and outdoor track in 1996, winning five all-state championships and seven state Division I championships. He was named the Massachusetts coach of the year twice. Comeau is in the Massachusetts Track Hall of Fame and the Punchard-Andover High Hall of Fame. He is pictured with his daughter, AHS track star Courtney Comeau. (Courtesy of the Comeau family.)

Ernest J. Perry

In 2010, "EJ" Perry became Andover High's football coach, taking the team to a conference championship and the playoffs for the first time in 35 years. In 2012, he duplicated the effort and added volleyball coaching to his tasks in 2013. He was named *Eagle-Tribune* Coach of the Decade (male) in 2010 for winning eight state championships for Salem, New Hampshire—two in basketball and six in volleyball. As an athlete at Andover High ('83), Perry was MVP in football, captain and MVP in basketball, and state class B champion pole vaulter. He was Andover's male athlete of the year. Playing basketball at Colby College, he was a four-year starter, the MVP for two years, captain, and All–New England.

Perry comes from a remarkable family of athletes. He and his four brothers may be the most remarkable siblings in the sports history of the town. His brothers John and Matt were captains of three sports at Andover High. In addition, John was *Boston Globe* All-Scholastic in football and basketball, as was his brother Tim. Another brother, James, played for Malden Catholic and was *Boston Globe* All-Scholastic in football and basketball. This does not appear to be a generational fluke, as the track in Lawrence is named for Perry's grandfather.

The Andover/Lowell football game on November 12, 2010, took place in Perry's first year coaching Andover, and it made national news. Tied at 28 points at the end of regulation, the two teams went into eight overtimes—a state record—with Andover winning 88-80— another state record for the number of points in a game. Andover's Andy Coke scored 64 points, also a state record. (Courtesy of *Eagle-Tribune*.)

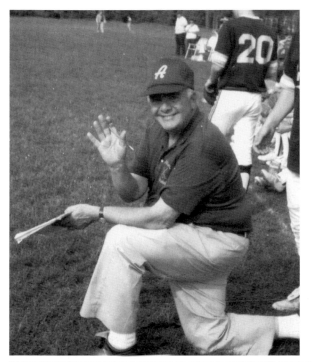

Theodore C. Boudreau
In 1990, a plaque was placed on the baseball field at the Playstead. It reads, "This field is dedicated to Theodore C. 'Ted' Boudreau by his family, friends and players. It was here, over his lifetime, that Ted spun his magic as teacher, coach, and friend. We shall never forget him or his efforts on behalf of the people and youth of Andover." The word "player" could have been added to the plaque, as many of Boudreau's legendarily long home runs happened on that field. Beyond left field and into the side of Ramcat Hill some of those homers flew. Boudreau (1927–1989) was such a good catcher and hitter that he played for the New England All-Stars at Fenway Park against the Boston All-Stars in the 1940s. The Ted Boudreau Memorial Award is presented to the town's Little League champions. (Courtesy of Betty Boudreau.)

Arthur Yancy
Yancy graduated from Andover High in 1965 and was the first Greater Lawrence athlete to receive a full basketball scholarship from a Division 1 school, Oklahoma City University, where he started for three years. He was the head basketball coach of the Greater Lawrence Technical School from 1976 to 2002 and was director of physical education and health. He won numerous conference championships and won the Greater Lawrence Christmas Tournament in 1985. He is in both the Punchard-Andover High and Greater Lawrence Technical School Halls of Fame. (Courtesy of Arthur Yancy.)

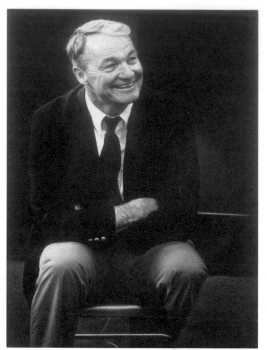

Sidney J. "Sid" Watson
Watson (1932–2004) played in the NFL for four years after being an outstanding athlete at Punchard and the greatest football player in the history of Northeastern, where he averaged more than 100 yards a game as a running back and was therefore nicknamed "Century Sid." In 1958, he became Bowdoin's hockey coach, and in 1984, he moved to athletic director. Bowdoin's 1,900-seat hockey arena, built in 2009, was named for him and is nicknamed "The Sid." He is in the Punchard-Andover, Bowdoin, Northeastern, Maine Sports, and United States Hockey Halls of Fame. (Courtesy of Bowdoin College.)

Ryan Hanigan
A catcher for the Cincinnati Reds since the 2007 baseball season, Hanigan graduated from Andover High in 1999, playing for Coach Ken Maglio. At Rollins College, he played three seasons with one of the highest batting averages in the school's history, and he turned professional before his senior year. He is one of the best defensive catchers in baseball, and a video of his catching would be a fine tool to coach catching to youngsters. He is the first person from Andover to play in the major leagues. (Image courtesy of the *Eagle-Tribune*.)

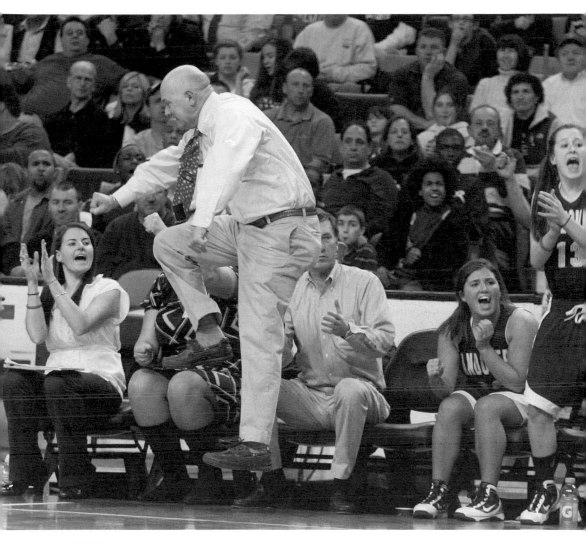

James Tildsley

Tildsley has a girls' basketball record that will likely never be matched. He retired in 2013 after 18 seasons as coach for Andover High School. During his career, his teams won four Division I state championships and made the playoffs every year. His record was 387-60. In addition to the state championships, Tildsley added seven Eastern Massachusetts championships, eight north sectional titles, and twelve conference championships. Of the four state titles, three were in the Nicole Boudreau era, occurring in consecutive seasons (2010, 2011, and 2012), when the team, led by Boudreau's scoring, lost only four games. They were undefeated in the 2012 season. In Tildsley's first three years, he had the Muller twins, Charlotte and Sarah, and they lost only seven games, culminating in an Eastern Massachusetts championship. Tildsley is quick to credit his players, but excellent talent requires great coaching, and Tildsley supplied that. Nicole Boudreau, speaking fondly of Tildsley, said he was hard on her, always trying to make her better. (Courtesy of the *Eagle-Tribune*.)

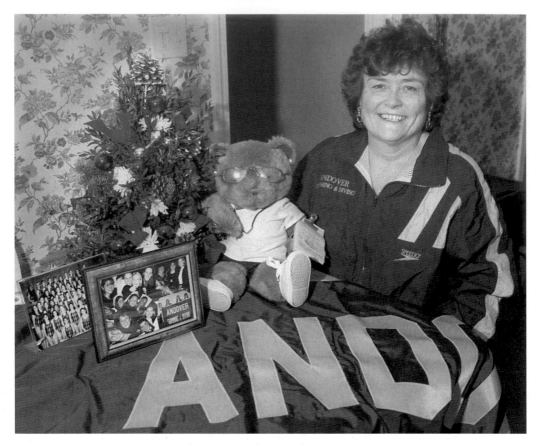

Marilyn DeMoor Fitzgerald

When she was captain of the Andover High School cheerleaders in 1962, Fitzgerald never could have dreamed she'd one day be named *Eagle-Tribune* Sportsperson of the Year (1996) and female Coach of the Decade (2010). As of 2013, she had coached the Andover High School swimming and diving team to 13 state championships and 14 conference championships in 14 years. Since 1992, Fitzgerald has coached 24 high school All-Americans. She says that any coach would be happy with one of those athletes, and the town of Andover had them all. Of the 24 All-Americans, 4 were divers, and of the 20 swimmers, 8 received the Massachusetts Swimmer of the Year award, and a pair of them won that award more than once: Connie Brown (class of 2003) won it three times, and Rachel Moore (class of 2012) won it twice. Brown, who is Coach Fitzgerald's granddaughter, set every swim record in the state but one. Moore broke many of Brown's records four years later. The number of college scholarships awarded to her athletes is extraordinary, and Fitzgerald is truly legendary. (Courtesy of the *Eagle-Tribune*.)

Richard Collins

Collins has had such a magnificent coaching career that the high school field house is named for him. Collins says this about coaching, "It is the self-satisfaction an athlete gains from playing a sport that largely determines a successful coach. A good coach tries to deal with each athlete differently. One of the most important things is for a coach to keep an eye on a kid who isn't improving quickly but is trying hard and to pat that kid on the back and to tell him or her that he's doing well and to keep it up." Collins says that working with parents is an important part of coaching kids, and he and his coaching staff always made a conscious effort to keep parents involved.

When he came to Andover in 1959, Collins took over as football and track coach. Although Andover always had a good track program, its football program was below average, and he turned that around. From 1973 to 1975, his football teams went to the state super bowl three consecutive years, winning the last two times. In 1972, his team lost its first game and then started a regular-season winning streak of 40 games. In track, he took a good program and made it into a great program. His results were amazing in both winter and spring track. He won 80 dual meets in a row, including numerous state and conference titles. He was picked National Track and Field Coach of the Year and is in the New England Hall of Fame for both football and track. Collins was a top-notch history teacher at the high school, and he taught at Phillips Academy during its summer program.

When Collins retired from teaching, he was elected to the school committee, serving 15 years until he retired in 2013. He has been involved in the Andover Schools for 54 years, which must be a record. He served as a football coach at Merrimack College when the program was being created, and he has helped out coaching at Phillips Academy, where, as an athlete, he once held a sprint record. (Courtesy of the Collins family.)

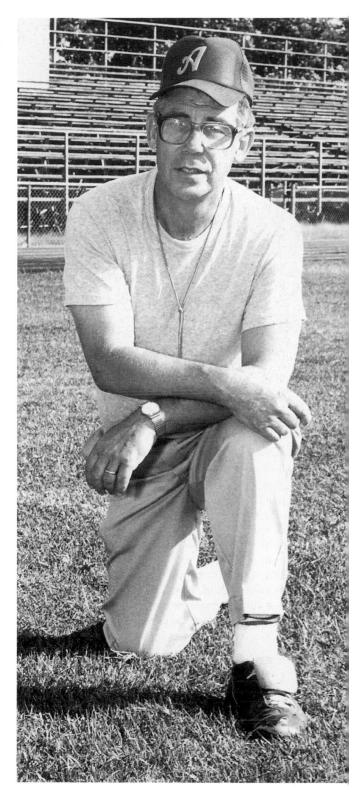

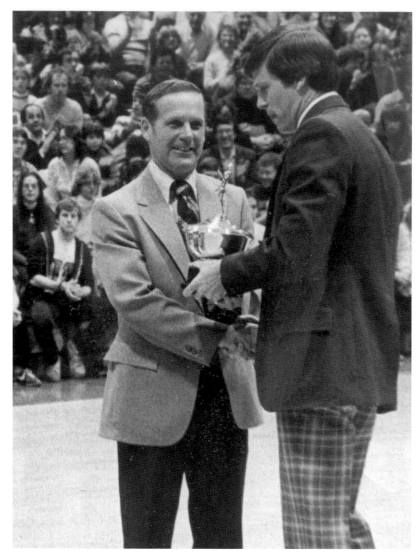

Wil Hixon and Dave Hixon

Two Hixons, Wil (left) and his son Dave (right), were inducted into the New England Basketball Hall of Fame in the same year, 2003. Wil Hixon started coaching and teaching at Andover High in 1958 and compiled the best boys' basketball win-loss record in the school's history, 377-122. Winning several conference championships, he also won a state title in 1970, when Dave Hixon was playing as a junior. Before coming to Andover, Wil coached teams that won two state titles in New Hampshire, making his overall basketball record 469-146. After spending a number of years teaching in the Andover schools, Hixon became an assistant principal, and was principal for his last four years before retiring in 1991. Andover High was picked as one of the country's 10 best schools in one of those years. In college, Wil was an outstanding baseball player and is in the Plymouth State College Hall of Fame for both baseball and coaching. Retired, Wil lives in New Hampshire with his wife, Dawn, who worked at the high school for many years. In 1977, two years after Dave Hixon graduated from Amherst, he became the school's head basketball coach. In 36 years of coaching, he has compiled a 693-252 record, winning two Division III national titles (2007 and 2013). He reached the finals a third year and six times was in the Final Four. Dave Hixon was named National Division III Coach of the Year in 2007 and 2013. (Courtesy of the Hixon family.)

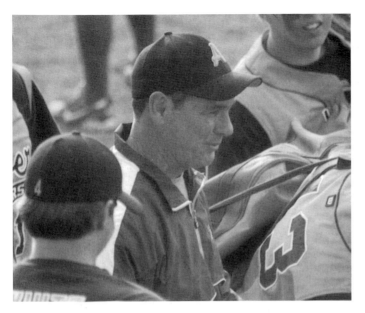

Kenneth Maglio
Ken Maglio, who retired in 2010, taught and coached in the Andover Schools for more than 40 years, eventually coaching varsity football and baseball. His record in baseball will qualify him for the state hall of fame. He says the most important lessons he learned from coaching were to be respectful and honest with kids, and that a coach's ego should never interfere with his players' game. In all his years of coaching, he never received a penalty for unsportsmanlike conduct. (Courtesy of the Maglio family.)

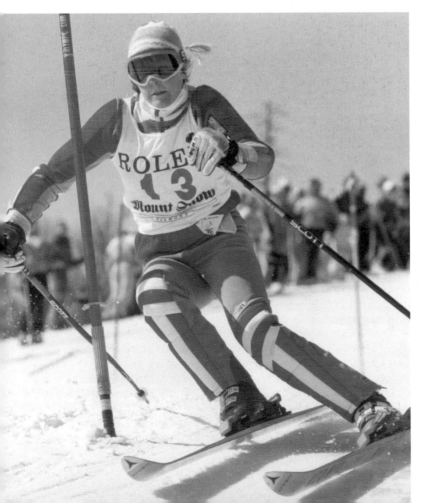

Amy Heseltine
Heseltine (AHS 1992) captained her soccer and ski teams and was undefeated skiing as a junior and senior, making the *Boston Globe* All-Scholastic Team and being the *Eagle-Tribune* MVP both years. At Providence College on a soccer scholarship, she was captain. She then captained the semipro Boston Renegades for four years. In 2006, she was inducted into the high school hall of fame. Amy's sister, Kim, a four-year starter in track and skiing, captained skiing and was an *Eagle-Tribune* and conference all-star for two years. (Courtesy of the Heseltine family.)

55

Fred B. McCollum

Friends all their lives, McCollum and Robert Phinney (see page 57) played for the old Shawsheen Maroons baseball and football teams as kids. They grew up on Enmore Street, were the same age, played three sports together at Punchard High School, and graduated together in the class of 1946. In McCollum's senior year, he became one of the few, and likely the last, high school athletes in Andover to letter in four sports in one year. On days when the baseball team wasn't playing a game, McCollum would run in track meets as a sprinter, earning two letters for two spring sports. He was captain of football and the team's star running back, being named to the Greater Lawrence All-Stars and an honorable mention for the Massachusetts All-Stars. McCollum started on offense and defense for three years in football, started as a guard in basketball for three years, and was a baseball standout at second and third base for three years. When he graduated from Punchard, he went into the Navy. He moved to California, coached high school basketball, served as an assistant coach for many teams, and was president of the local boosters club. McCollum enjoys watching his grandchildren play sports. Shown here are, from left to right, Bob Phinney, Connie McCollum, Sandra McKinery (front), and Fred McCollum. (Courtesy of Fred McCollum.)

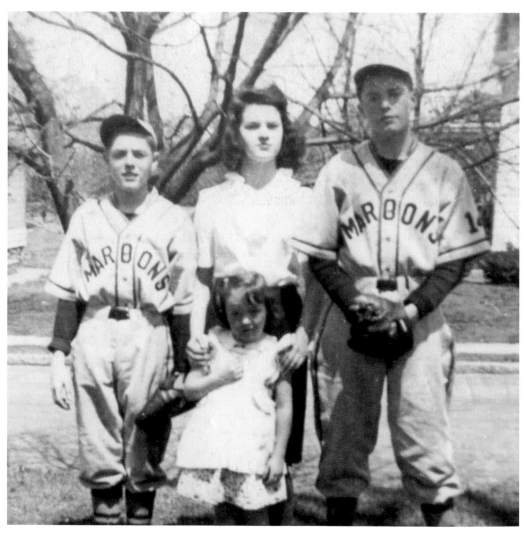

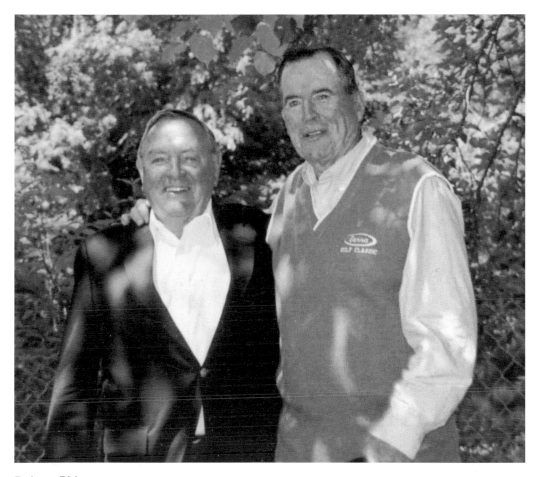

Robert Phinney

Bob Phinney was a fine three-sport athlete at Punchard, and he captained the basketball team. Following his graduation from Merrimack College, he went to work with his father, Harold, at Temple Radio. Eventually, the store was called Phinney's, where Bob Phinney sold a lot of records and televisions. However, his last job, managing the LANAM Club for 15 years before retiring in 1996, may have been his most rewarding. Many notables, such as former president George H.W. Bush and Jay Leno, visited the club. Phinney was a popular, likable, and gracious host. He was president of the Men of Merrimack, president of the Big Brother, Big Sister Association of Greater Lawrence, and the head of the Andover Board of Trade.

Both Fred McCollum (right) and Phinney (left) played a lot of golf, and it was on their agenda when they visited each other once or twice a year. They remained good friends until Phinney's death in 2007. (Courtesy of Fred McCollum.)

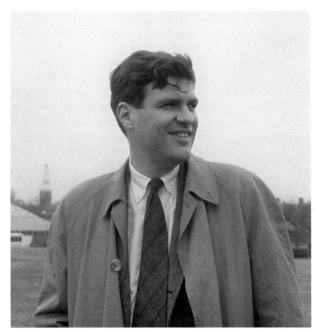

Theodore R. "Ted" Sizer
The day after the "Blizzard of 1978," Phillips Academy headmaster Sizer received a call from the town's police department, asking if the school had any kids with shovels. Kids and shovels, 150 strong, dug out elderly housing, the Andover Town House, and other key buildings. Sizer (1932–2009) was headmaster from 1972 to 1981, during the time the school merged with Abbot Academy. A leader of educational reform, he wrote a book trilogy, starting with the widely read *Horace's Compromise* in 1984, which stays relevant today. (Courtesy of Phillips Academy Special Collections.)

Dudley Fitts
Fitts, a poet who taught English at Phillips Academy, was best known for his translation of Greek and Latin literature and his teaching skills. Paul Monette, winner of the National Book Award in nonfiction, wrote, " I lucked into Dudley Fitts's English IV. He was the one true Olympian on the Faculty. The Sophocles we used in class had been translated by him . . . a feat of erudition that seemed almost Biblical." Fitts (1903–1968) is buried in the old Phillips Academy cemetery. (Courtesy of Phillips Academy Special Collections.)

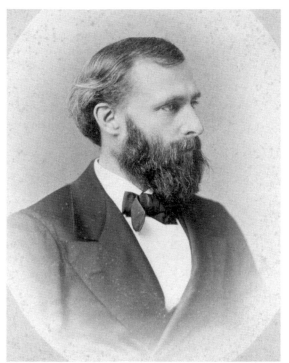

Cecil F.P. Bancroft

In 1878, Phillips Academy was declining in attendance and finances, but Principal Bancroft put together a successful school centennial, including a fund drive. Townspeople obliged by contributing and opening their homes to visiting alumni. The centennial fund exceeded expectations, and the academy has been financially strong since. In 1896, Bancroft (1839–1901) chaired the town's 250th birthday. (Courtesy of Phillips Academy Special Collections.)

Thomas Lyons

History teacher Tom Lyons (1924–2012) said that the worst thing a teacher can be is dull, and he was anything but dull. He was a teacher, school newspaper advisor, and mentor to 36 years of Phillips Academy students. Lyons retired in 1999. Polio struck him in college, necessitating his use of crutches and a wheelchair, but it did not interfere with his fast-paced classes, which often found Lyons with his shirt untucked and covered in chalk. Pres. George W. Bush said Lyons was one of his most influential teachers. (Courtesy of Phillips Academy Special Collections.)

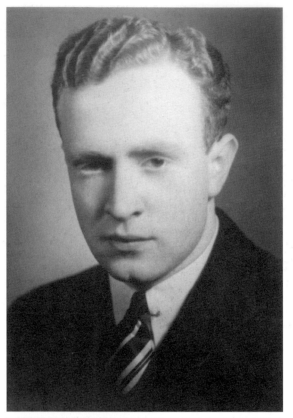

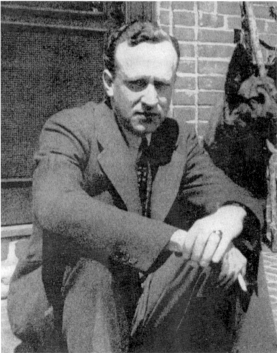

Bernard M. Kellmurray

A genius with an incredible memory, "Kel" memorized Hamlet, Macbeth, and many other great writings. He was legally blind while teaching high school, and he was occasionally seen reading from books while holding them upside down. When he recited, his eyes wandered above a book as if making eye contact with everyone in his class, although he could only see the first two rows, and even those students were blurred to him. His glasses were so thick that they acted as magnifying glasses, making his blue eyes huge. When he read, the paper and his glasses were so close they almost touched. Kellmurray (1910–1966) taught English, and there was no grade inflation. He used a heavy red pencil when he graded papers, and many came back to the students looking like a slaughter had occurred. His precise questions in class were designed for students to have epiphanies. He was a teacher almost everybody liked, with many former students saying he was the best they ever had.

Kellmurray's Yale yearbook (1932) said he wanted to go into movie production work. In 1936, he went totally blind, requiring a guide dog. Two years later, Kellmurray returned to Yale, receiving another degree by reading in Braille. In 1941, he inexplicably and miraculously regained some sight. His medically unexplained loss of sight and sudden improvement made news all over the country, including in the *New York Times* and the *Saturday Evening Post*.

After doing support work in Washington during World War II, Kellmurray was hired at Punchard High as both a teacher and guidance counselor. After he dropped being an official guidance counselor, he unofficially acted as an advisor and mentor. A college recommendation letter from him was important, and he wrote each one with care. He was truly a teacher who cared, and he daily overcame his sight problems to show it. (Top, courtesy of the Reilly family; bottom, courtesy of the authors.)

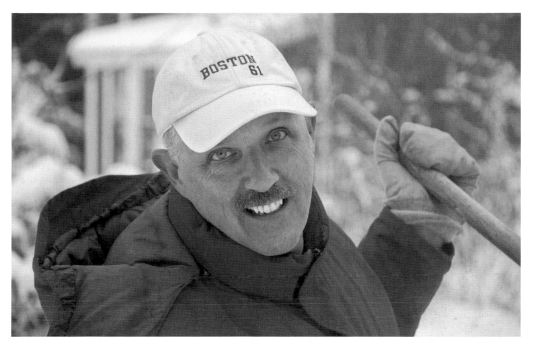

James S. Batchelder
In 2005, Batchelder received the Rotary Club's Citizens Who Care Award. The multitalented Batchelder is an artist, retired art teacher, and historian. He taught in the Andover Schools for 33 years, headed the art department for five years, and was teacher of the year in 1979. Batchelder has volunteered to do public art associated with Andover, including the town's bicentennial celebration logo and a postal service cancellation stamp for the Town House rededication (below). He is a longtime member of the Andover Historical Society Board of Directors, serving as president from 1992 to 1994, and has done numerous projects for the society, including chairing the publications committee for *Andover: A Century of Change* (1995). He has been on the Andover Preservation Commission since 1994. (Both, courtesy of Jim Batchelder.)

Catherine Barrett, Alice Stack, and Eunice Stack (ABOVE AND OPPOSITE PAGE)
Barrett (opposite page) and the Stack sisters (above) brought fear to the bravest of students entering Stowe School, which comprised fifth and sixth grade in the mid-20th century. However, once the students were at the school, they realized that there was nothing to fear as long as they behaved and did their work. After they moved on to junior high school and, especially later, when they grew up, they realized how lucky they were to have gone to the school. Barrett was the principal, and she was everywhere, making sure her students were being good and that nothing was wrong. The Stack sisters were excellent teachers who also believed in discipline. (Three other Stack sisters taught elsewhere, no doubt equally as good.) The worst thing that could happen to a student was to be told to visit the principal because he or she had misbehaved. That visit was called "going up," because Principal Barrett's office was on the top floor. Fellow students would ask, "Do you have to go up?" as if the electric chair were there. One visit to her was all that was necessary for most students. Only fools made the same mistake twice. The three women were similar in one respect; as soon as they felt a student was serious about school, they became, if not friends, interested in the student, guiding him or her to achievement. Once a student graduated from the school, he or she might see one of the women and receive a pleasant inquiry as to how everything was. Then, they became the former student's friends. (Opposite photograph by Richard Graber, courtesy of Jennifer Graber; above, courtesy of the Stack family.)

J. Everett Collins

Known as "Ev," "Everett," or even "J. Everett" to his friends and townspeople, Collins was one of Andover's most remarkable people. Born on Barnard Street, he graduated from Punchard High School in 1913 and was a combat veteran of World War I. In 1983, the J. Everett Collins Center for the Performing Arts, next to the high school, was named for him, and he was the first person inducted into both the Punchard-Andover High School Athletic Hall of Fame and the Fine Arts Hall of Fame. He was one of the best high school football and baseball players of his era. Collins (1894–1986) was a state representative for 14 years, a selectman for 21 years (1935–1956), and a school committeeman for 1 year. He was on the finance committee and the town's tercentennial committee. Collins founded the Andover Men's Choir in 1921 and then the Andover Choral Society, which, beginning in 1929, performed Handel's Messiah for 55 years under his direction. He was a choral director in the Andover Schools from 1960 to 1980. During a lengthy recorded interview in 1983 with a local newspaper columnist, Collins said the following: "High School was the best time of my life. I loved sports and fell in love with Elizabeth Abbot, who became my wife. I was in sports, school shows, and I was earning money from my singing. After graduating from high school, I worked at Tyer Rubber. One day I was asked to play baseball in Manchester. They needed a catcher and paid me $10 for one game. I'd work more than 40 hours a week at Tyer and only make $8. Back then you could buy a good suit for $10. . . . I've worked, worked, worked to get what I wanted. . . A lot of people today don't give a damn about the town. We were brought up to love it, just like we loved our country. There was a tremendous pride in the town." His son, Roger, was a selectman from 1964 to 1974, and was a member of the zoning board of appeals for 10 years. (Photograph by Richard Graber, courtesy of Andover High School.)

CHAPTER FOUR

Service in Uniform

From the earliest days of Andover's history, a strong local militia was the best deterrent from Indian attacks. At times of high vigilance, militiamen were sent into outlying fields to protect settlers while they worked. Andover men fought and died in the French and Indian Wars and Revolutionary War. In the Civil War, three Andover men were awarded the Medal of Honor. Many Andover men served in World War I, one of whom returned to become an Andover policeman who was shot and killed on Main Street. The Andover police and fire departments have long traditions of service. The police department traces its beginnings to the constables that enforced laws in Andover's colonial days, and the fire department's birth came shortly after the Civil War, when volunteers formed a fire brigade and owned a fire wagon. Both departments have traditions of fine leadership and honor.

Andover men and women were willing to do what was asked of them in World War II, the Korean War, the Vietnam War, and the war against terrorism. Some paid the ultimate price, and some received terrible wounds. In recent years, the town has recognized its war veterans by placing memorials throughout the Park. The excellent book series Heroes Among Us, created by Andover's Department of Veteran's Services, uses veterans' own stories to explain what he or she did during wartime service, beginning with World War II.

Warren "Buster" Deyermond

Deyermond (AHS '66) was liked by everyone who knew him. He was co-captain of his baseball team and president of the varsity club. He was killed in Vietnam while on patrol. The monument at Deyermond Park reads, "Dedicated in memory of a beloved son of Andover who carried on the family tradition of duty, honor, country. Buster was an outstanding athlete whose greatest joy in life was having a catcher's mitt on his hand, the sun and dirt on his face, and hearing the sound of a bat hitting a ball. He was a kind, generous, funny, and loyal kid whose heart was only outmatched in size by his broad, every-present smile. He will be forever missed by those who knew him, and may this complex serve as a tribute to him and all those who gave their lives in service to their country. Truly, his was a life unfinished."

Andover has lost many people in war, and many more have been seriously injured. Buster Deyermond (1948–1969) would have been the first to ask, "Why pick me for this honor?" It is because he is a good representative for all men and women who put their lives on the line as the price our country pays for freedom. (Courtesy of the Deyermond family.)

Calvin A. Deyermond Jr., John Deyermond, and Michael Deyermond

Cal Deyermond (AHS '64, at left in the photograph) jokes that the Deyermonds have in abundance a gene that causes them to be in uniform. Many Deyermonds, male and female, have traded one uniform for another, such as a military uniform for a police, firefighter, or nurse uniform. Cal went into the Army the same year that his brother Buster was killed in Vietnam. He was selected to attend Command Infantry School and served as a platoon drill sergeant. In 1976, he became a Lawrence police officer. While rising through the ranks, he supervised or commanded every division within the department, received a master's degree in criminal justice, and was selected to attend the prestigious FBI National Academy. Retiring in 2006 as a captain, he was employed by LoJack, where he is the law enforcement liaison. He serves on the Andover Housing Authority Board of Commissioners and the town's patriotic holiday committee.

John Deyermond (center) entered the service to honor his cousin Buster and retired as a major general. Both he and his wife, Barbara (Poschen) Deyermond, graduated from Andover High in 1967. After enlistment as a private, John went to Army Infantry School, graduating as a second lieutenant. He and Barbara both liked Army life, enjoying the opportunity to travel and serve in various posts around the world. The couple says that the Army got a two-for-one deal. John says that his most difficult command assignments were in Bosnia and Kosovo, working as part of a coalition of military forces. He says that a commander is responsible for everything or anything that happens or fails to happen within his or her command organization. One cannot blame subordinates or predecessors.

Michael "Mickey" Deyermond (right), Buster's brother, was in the Army from 1973 to 1995. He served as a first sergeant in Germany and in Iraq during Desert Storm. He is now the operations manager for the Verizon Wireless Sports and Entertainment Center in New Hampshire. Not pictured is Mary Jo (Deyermond) Sinnott, Buster's sister, who was Navy active duty from 1984 to 1988. She is a registered nurse and lives in Florida. (Courtesy of the Deyermond family.)

William Marland, Henry F. Chandler, and Frank S. Gile
The Medal of Honor, the highest military award given by the United States, was created during the Civil War. Three Andover men won the Medal of Honor in that conflict: Army lieutenant William Marland (pictured), Army sergeant Henry Chandler, and Navy landsman Frank Gile. Marland stayed active in Andover and served on the town's 250th anniversary committee. (Courtesy of AHS.)

William F. Bartlett
So inspirational was Civil War general Bartlett (1840–1876) that the Andover GAR Post and Bartlett Street are named for him, and his statue is in the State House. Enlisting as a private while at Phillips Academy, Bartlett was a major general by age 24. His heroism saved 75 men in one battle. During the war, he lost a leg, the use of several fingers, was shot in his good leg and the head, had his wooden leg broken, and, while a Confederate prisoner, contracted typhus. Bartlett came back every time, but he never fully recovered and died in his thirties. (Courtesy of Trustees of the Haverhill Public Library, Special Collections Department.)

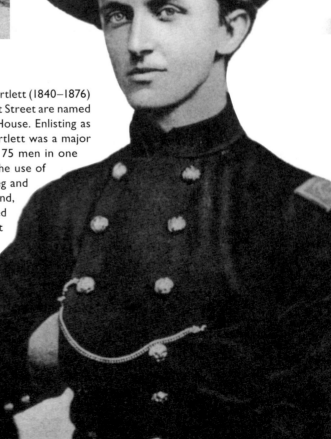

Contributors To The Cause...

Salem Poor *Gallant Soldier*

Salem Poor

A bicentennial 10¢ stamp was issued to honor Andover's Salem Poor 200 years after his heroism at Bunker Hill. As an infant, Poor (1747–1802) had been purchased at a slave auction. He bought his freedom at age 22 and married another former slave, Nancy Parker, who may have been part Indian. The couple had a son, Jonas. Salem Poor enlisted in Capt. Benjamin Ames's Andover Company and fought bravely at Bunker Hill, being one of the last to retreat and killing an English lieutenant colonel. The general court was petitioned by 14 colonial officers to reward Poor, but no action was taken. Poor was discharged in 1780. He married three more times, living in Boston and dying in an almshouse. Nancy Parker Poor, a wild-looking woman, possibly living in a wigwam near Carmel Woods, was fond of saying cuss words, but she worked hard as a traveling spinster. Jonas disappeared from the records. (Courtesy of John Flannery, aka DrPhotoMoto.)

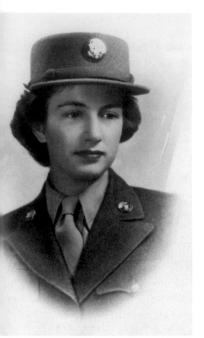

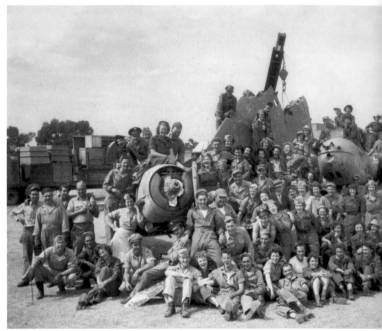

Dorothy Muise Volker

While at Punchard, Dorothy "Dot" Muise was a member of the All-Girl Band the first years of its existence. She wanted to be a drummer, but her mother required she play the trumpet. Miriam Sweeney, the leader of the band, promised an ice-cream soda to the person who practiced the most; Muise won the soda every week. Muise graduated at age 16. World War II was raging, and Muise played in the American Legion Band, where she finally got to play the drums. In 1944, at age 18, Muise was two years younger than the necessary age to enlist in the WAC/AAF (Women's Air Corps of the Army Air Force), so she forged her birth certificate. After five weeks of basic training, she was selected to travel the country with the "Shot from the Sky" show, under the direction of Gen. "Hap" Arnold. It was a big show, displaying trophies of the war, such as shot-down German and Japanese planes. The selected WACs were pretty and personable, to facilitate the selling of war bonds. When the show was in Boston, Muise went temporarily AWOL to bring her family to see it. Following the tour, she was assigned to Bolling Field, Washington, DC, and she met Robert Volker. They were married a month later. She was discharged in March 1946, receiving the American Service Medal, the Victory Medal, and the Good Conduct Medal.

Dot Volker convinced her husband to move to Andover in 1948, and they lived on Washington Avenue. Volker, brought up on Park Street, thought Washington Avenue was "out in the sticks." She became Andover's first sworn full-time female police officer and worked as a crossing guard and clerk. Eventually, she became Chief David Nicoll's administrative assistant. She retired in 1980 and still does volunteer work in the municipal offices and is a regular at the senior center. She and her husband were married for 50 years before he died. (Both, courtesy of Dorothy "Dot " Muise Volker.)

Michael Burke

Burke has a total of 24 years in the service, active and reserve, and is currently a major in the Army Reserves. He was mobilized on September 11, 2001, for Operation Enduring Freedom (Afghanistan) and, later, Operation Noble Eagle (Homeland Security). Burke received the Bronze Star for his actions. He started his civilian job as director of veterans' services in 2007. His predecessors were John Doherty, an Army combat veteran of the Vietnam War, and John Lewis, a Navy Pacific theater combat veteran of World War II and Korea. Lewis was director for 27 years. Burke started and is overseeing the excellent Heroes Among Us project, in which Andover war veterans tell their stories. Like his predecessors, Burke has worked hard to ensure that veterans are recognized for their service. Burke has a philosophy about his work, saying, "I do anything and everything I can do for our community veterans." In the photograph at left, Burke is seen in Somalia in 1993. Below, Burke (right) is at the 2011 Veteran's Day presentation of a book in the Heroes Among Us series, along with John Lewis (left) and Comdr. Robert Hamilton. (Both, courtesy of Michael Burke.)

Col. Edward M. Harris (1911–1977)

A 1935 West Point graduate, Edward Harris (seen here with wife Alice Rice Harris, c. 1947) was a man who knew his duty. His military career was largely devoted to the organizing and planning of things clandestine, and he taught at West Point for three years. Upon retirement in 1961, he accepted a position at Phillips Academy teaching Spanish and, while there, instituted what became known as School Year Abroad, one of the first programs of its kind in the country. A few years after retiring from PA in 1971, Harris worked on Andover's bicentennial committee and wrote *Andover in the American Revolution*. In 1977, he was elected selectman and, following his first term, he decided to retire. However, no one else in town wanted to run, and on the day that nomination papers were due, other selectmen urgently asked Harris to reconsider. He knew his duty and was soon on the sidewalks asking for signatures on his nomination papers. His second term ended in 1983, and he had just been elected vice president of the Andover Historical Society when he died. Harris was always a gentleman with a pleasant demeanor. He chose his words carefully, and when he spoke, people listened. In 1984, the flagpole in front of Andover's municipal offices was dedicated to him. His son George R. Harris (1947–2005) was also a man who knew his duty. He served as an artillery forward observer in Vietnam, a job with a high casualty rate, as they are considered priority targets by enemy forces. Only three days after Harris was replaced, the new artillery forward observer was killed. Harris volunteered to return to the position, so he did the dangerous work again. In Andover, George Harris served many years at the polls and town meetings. In 2007, the flagpole was rededicated as the Harris Family Flagpole, to honor both father and son. (Courtesy of the Harris family.)

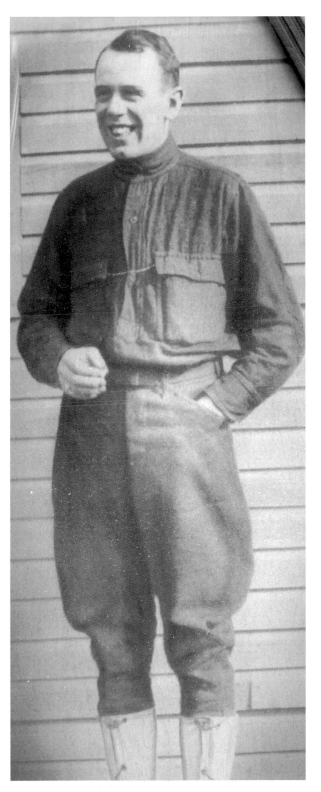

Officer Robert T. Black (1896–1925) On November 27, 1925, at 10:30 p.m., Andover police officer Robert T. Black was killed in the line of duty, the only member of the Andover police force to suffer that fate. There had been a holdup in Lawrence, and Black received a call on a Main Street call box describing the car involved in the robbery. Soon, Black saw a car fitting the description coming through Elm Square with a smoking wheel. Black ran after the car, but the driver stopped the car and ran down Chestnut Street, too far ahead for Black to find him. Then, 20 minutes later, Black saw a man walking on Main Street toward Elm Square. Black moved quickly and closed the gap between them, and witnesses said the man turned around as if to ask Black a question, but, when they were separated by only three feet, the man brought up a handgun and shot Black twice. One bullet hit Black's chest and one sliced an artery in his neck. He fell down, pulled out his own gun, and fired four shots at the criminal. Black died before reaching an operating table.

His death became legend. Rumors persisted for decades that Black had been killed by a local man over a private issue. These rumors were bolstered by an *Andover Townsman* editorial on the 35th anniversary of Black's death; it said, "somewhere this week, feeling safe and secure, lives a man who calmly murdered Black, and that even today [in 1960] residents who remember the event claim the authorities knew who the man was but could never prove a case against him." The article infers that the person who fled down Chestnut Street was a nervous youth and that the stranger who appeared on Main Street and casually shot Black was a different person. Annually, the Robert T. Black Award is given at the Andover Policeman's Ball to an Andover officer who performed meritorious service that year. (Courtesy of Andover Police Department.)

David L. Nicoll (1915–2003)
He walked Main Street with a deliberate slowness, glancing around to be sure everything was in order. Respected by his men and the community, Nicoll was the consummate police chief, holding that job from 1952 to 1979. Athletically built and six feet, four inches tall, he was soft spoken, careful of his words, and had a brilliant mind. Valedictorian of his Punchard High School class, Nicoll served in World War II before returning to Andover. Unflappable, he'd speak at the town meeting as confidently as he walked Main Street. (Courtesy of Andover Police Department.)

Harold Hayes
Hayes was five when his father died. He lived next to fire chief Edward Buchan and watched the chief's red car come and go when the fire horn blew. From then on, Hayes wanted to be a fireman. He joined the Andover firefighters in 1960, and, before he was 30, he was a deputy chief. He became chief in 1972. Hayes proposed that Andover have a fire inspector, and he was the town's first one. He did not get along with the union, but was well liked by everyone else. No one ever had to wonder what was on his mind. While chief, Hayes nominated Andover's first female firefighter, Maryann Frechette, in 1988. Chief Hayes retired in 1996. (Courtesy of Harold Hayes.)

CHAPTER FIVE

Service to Community

Arriving from Ipswich, Simon Bradstreet led the first group of the town's settlers in 1645. He, along with the town's minister, was the final arbiter of important decisions. Later in life, Bradstreet would be governor of the Massachusetts Bay Colony. His son Dudley was also an eminent citizen. Not long after incorporation, the town of Andover adopted an open town meeting government, whereby critical decisions were made in a democratic fashion by landowning men. The controversies surrounding the split of Andover into two parishes in 1707 and then the split into two Andovers in 1855 were emotional and potentially volatile, but town meetings provided an opportunity for people to vent and discuss the issues.

The Bradstreet tradition of service to the community was carried down through history by thousands of men and women. Several went on to serve the state and country as well as Andover. The number of people who served the community is large; this chapter features a representative sample of such citizens.

William R. O'Reilly, MD
The personable and beloved O'Reilly was an honorary member of both the fire and police departments. He was a pioneer in the delivery of emergency medical services in Andover and voluntarily appeared at fires and accidents in the event that a physician was needed. In 1959, he became the first doctor in Andover to devote his practice to pediatric medicine. O'Reilly (1927–1999) was chief of the medical staffs at Lawrence General and Holy Family Hospitals, and he received numerous humanitarian awards. (Courtesy of Christopher O'Reilly.)

Larry L. Larson, PhD
Larson was a selectman from 1991 to 2000 and is a charter member of the Andover Service Club. He has been a child and adolescent psychologist in Andover for 40 years. A polymath, Larson has been a newspaper owner and publisher, a real estate developer, a writer, and has taught at two major universities in Boston. He has been president of, and served with, numerous other community and professional organizations that work with children. (Courtesy of Mark Spencer.)

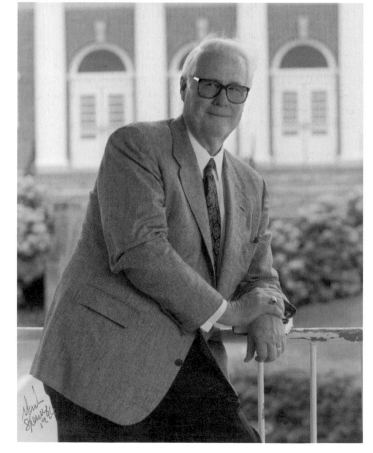

Charles E. Abbot, MD (1856–1931)
Described by a contemporary as "tall and erect, with a mustache and impressive shock of white hair," Abbot in middle age and beyond was distinguished and stood out in any company. As a doctor, his hours were, "Until 9 a.m., 1–3, 6–8 p.m. House calls in between." His office was at 70 Main Street. Abbot founded the Andover Historical Society in 1911 and did something else very important: led the Andover Board of Health during the Spanish Flu Pandemic of 1918–1919, which killed as many as 50 million people worldwide, he closed all public meetings, including churches, which likely contributed to holding the town's fatality rate to 25. He was elected to be Andover's representative to the general court late in his career. (Courtesy of AHS.)

Rev. Dr. Cal Mutti
Retiring from South Church in 2007, Dr. Cal Mutti said that one of his ambitions was to grow a 1,000-pound pumpkin. Late in his 19-year tenure as pastor, he led the congregation in voting to be an "open and affirming church," meaning it welcomed gays and lesbians. He was close to his pastorate, knowing them by name and being with them in times of personal crises. The Andover Rotary has created an honor in the name of its charter member: the Cal Mutti Service Above Self Award. He and his wife live on Cape Cod. (Courtesy of the *Eagle-Tribune*.)

Rev. Jack L. Daniel
In 1977, when Daniel became pastor of Free Christian Church, there were 75 members. When he retired in 2012, there were 1,200 members. While pastor, he oversaw three improvements to the church itself, including a $1.7 million building addition. For 15 years, Daniel and Rabbi Robert Goldstein hosted *Faith Matters* on public access television. Daniel is a legendary preacher and communicator, and the church now has a North Andover annex. He says he loves people and loves preaching. (Courtesy of *Eagle-Tribune*.)

Rabbi Harry A. Roth
Roth (right) oversaw the moving of Temple Emanuel from Lawrence to Andover in 1979. Future selectman Jerry Silverman was one of the people who carried the Torah to the new location. Roth served the temple from 1962 to 1990 and was involved in the ecumenical movement to the extent that he led a trip of local clergy to Israel. When Roth retired, Temple Emanuel was one of the largest Jewish congregations in the Merrimack Valley, with 400 families. Roth (right) is pictured with Cardinal Bernard Law. (Courtesy of the American Jewish Historical Society New England Archives, Boston.)

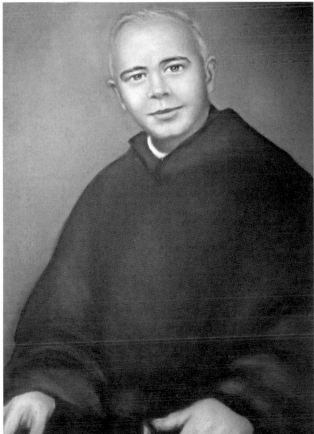

Rev. Henry Bernard Smith, OSA
Father Smith (1905–1963) served St. Augustine Parish from 1935 to 1963, the last seven years as pastor. He was respected throughout the community for his dedication to the town and for his interfaith activities. Under his watchful care, property was acquired next to St. Augustine School and converted to a convent and parish center, and the school was doubled in size, reopening in 1962. The overpass bridge on Route 28 near the Lawrence line is named for him. (Courtesy of St. Augustine Parish.)

Amos Abbot

Abbot (1786–1868) was Andover's most conspicuous political figure of the second quarter of the 19th century. Plainspoken and homespun, he was the first congressman from the South Parish and served three terms, including being whip. He had served as town clerk, town treasurer, and school committee member. He was in the line of Abbots who owned the Abbot Tavern (seen here), a structure still standing on Elm Street, where Pres. George Washington once had breakfast. Abbot was a founder and director of what became the Boston & Maine Railroad. (Courtesy of AHS.)

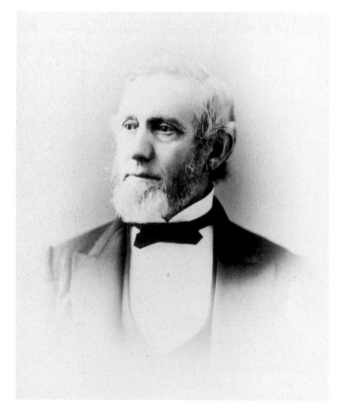

Marcus Morton Jr.

The Honorable Marcus Morton (1819–1891), for whom Morton Street is named, was the most important judge of his time in Massachusetts. He was one of the 10 original judges of the Massachusetts Superior Court, appointed in 1859. He was appointed to the Supreme Judicial Court, the state's highest court, 10 years later. Morton became chief justice in 1882 and held that post until he retired in 1890. He lived on the corner of Morton and School Streets. (Courtesy of Social Law Library, Boston.)

Sidney P. White (1899–1983) Some people in Andover did not like White, but a lot more did, and they kept reelecting him to office, sometimes to as many as three offices at one time. This was at a time when almost every office-holder was elected. Between 1949 and 1972, he was a selectman for 16 years. He had a strong personality and opinions; yet, those who knew him well described him as generous, and he had many friends. He owned Wild Rose Dairy Farm for many years, and in 1959, he opened the Rose Glen Dairy, which served ice cream on Andover Street. (Courtesy of AHS.)

Susan Treanor Poore Dalton Dalton served multiple terms on both the board of selectmen (1976–1982), where she was the first woman to be chair, and the school committee (1982–1991). Her eclectic background includes two years of study at Ecole Francaise in Copenhagen and jobs as teacher and ski instructor. She served on the board of directors of the Lawrence YMCA and was on the advisory board for CLASS (Citizen's League for Adult Special Services). In 1991, she became a lawyer and practiced with her husband, Charles F. Dalton Jr., until they retired in 2013. (Courtesy Susan T. Dalton.)

Richard J. Bowen

Dick Bowen is a man of many interests. After high school, he entered the Navy during World War II. Following the remainder of his education, he started a 25-year career in public administration. In 1964, he became Andover's second town manager. Bowen was elected selectman in 1976 and served until 1978, resigning to be a city manager in West Virginia. After returning to Andover, he went to law school at age 58, beginning a second career. In 1985, Bowen became a member of the Massachusetts Bar. The Lawrence Bar Association gave him its leadership award in 2005 for his "work as a bar advocate on behalf of children and adults." For the 15 years before retiring in 2012, he worked exclusively in the Lawrence Juvenile Court. Bowen served on numerous committees in Andover and was the first chairman of the Ballardvale Historic Commission. (Above photograph by Richard Graber, courtesy of Jennifer Graber; left, courtesy of the *Eagle-Tribune*.)

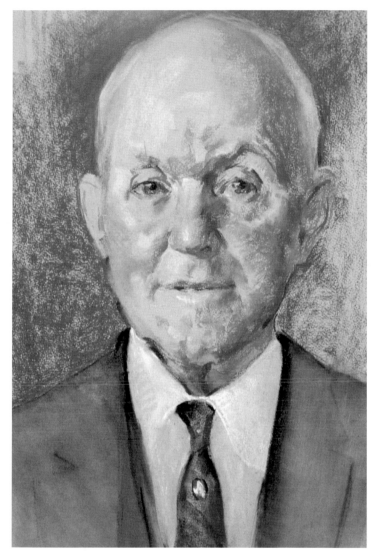

Frederick E. Cheever (1888–1975)

One of Fred Cheever's best moments occurred at a town meeting in the early 1960s, when the fate of the town hall, now called the Town House, hung in the balance. It appeared that the vote was headed toward tearing it down, but Cheever—well known, respected, and elderly—gave an impassioned speech to save the historic building, and it worked. Near the end of the speech, he offered a sizable donation of his own money toward restoring the building. Cheever lived in a house on Bancroft Road that had been occupied by his ancestors for 200 years. Both the house and barn were filled with antiques, and he left a large number of them to the Andover Historical Society, along with money for an exhibit room in the memory of his mother, Alice Bancroft Cheever. He developed Johnson Acres (named for an old Andover family that sold the land to Cheever), and Cheever Circle is named for him. He was a graduate of Punchard and served as postmaster before he went into the real estate and travel agency business. He was a frugal man who kept his business expenses down. Cheever's office, upstairs at 3 Main Street in the Carter Block, was a walk back into the 1920s. Late in his business career, he raised the ire of some realtors in Andover by refusing to raise his commissions when they did. He also served on the school committee and planning board. (Courtesy of AHS.)

Kenneth R. Mahony

Town manager Ken Mahony (1937–2008) got things done. Working in Andover for only eight years (1982–1990), he solved four long-term problems. He implemented plans that resulted in the town office building, the upgraded park, and the restoration of the Town House. Andover's finance director, Tony Torrisi, said that Mahony's creative contracting and financing saved the town $2 million. Additionally, the library's biggest expansion in its history occurred under Mahony. Shown here are, from left to right, (first row) Sue Tucker, Kenneth R. Mahony, Gail Ralston, and Gerald H. Silverman; (second row) Stan Corcoran, William J. Dalton, William T. Downs, and James D. Doherty. (Courtesy of Gail Ralston.)

Paul W. Cronin

At age 23, Cronin was elected selectman, serving from 1963 to 1966. A Republican moderate, he was elected state representative (1967–1969). In an upset, Cronin defeated John Kerry in a run for Congress in 1972. After being chosen the outstanding freshman congressman by his peers, he lost a reelection bid to Paul Tsongas in 1974, a bad year for Republicans following Pres. Gerald Ford's pardon of Richard Nixon two months before the election. Cronin (1938–1997) was appointed to the Massachusetts Port Authority by Gov. William Weld. (Photograph by Richard Graber, courtesy of Jennifer Graber.)

Kenneth Seifert, PhD
Ken Seifert was Andover's school superintendent from 1969 to 1991. He executed his job masterfully, and the schools thrived. The 1970s was a time of turmoil on the school committee: members quit, got sued, and sued in return. All the while, Seifert kept his head. He was the public voice of moderation while he moved the schools forward, taking them from average to exceptional. In recent years, he wrote a column for the *Andover Townsman*. (Courtesy of Kenneth Seifert.)

Frederick E. Teichert III
Ted Teichert was an Andover selectman from 2000 to 2012. He coached four different youth sports and has been involved in the Andover Junior Football League since 1980, working in every position from coach to president, serving in the latter role for 10 years. He took over championing the Fourth of July fireworks from the late Jerry Silverman. Teichert owns Ted Entertainment, a business that provides disc jockey service all over New England. His father and grandfather were both Andover businessmen. Teichert received the Distinguished Citizen Award from the Boy Scouts in 2013. (Courtesy of the Teichert family.)

Gail L. Ralston

A recent project to Ralston's credit is *Selectmen of the Town of Andover (Town Fathers and Mothers) 1855–2012*, which provides a summary of selectmen's accomplishments. She is one of the subjects, having been a selectman from 1987 to 1991. She was later on the Andover Conservation Committee and compiled a history of the 50-year-old committee. She serves as chair of the 104 Stories Committee of the Andover Historical Society, and she has written many of the stories. Among numerous current projects, she is a poll worker. Pictured are Richard L. Alden, Kenneth R. Mahony, Sue Tucker, Gail Ralston, William T. Downs, and William J. Dalton. (Image courtesy Gail Ralston.)

William T. Downs

Bill Down's public service is tough to match. He was a military policeman during World War II and was on the Andover Fire Department for 31 years (1955–1986), serving the last 10 years as chief. He and James Lynch were the first firefighters to become EMTs. He was elected to the board of selectmen in 1987 and held office for 12 years. He was an elected member of Andover's Retirement Board for 18 years and has been on the founder's day committee (honoring employee service) since 1965. Bill is pictured second from the right. (Image courtesy Gail Ralston.)

Norma Heseltine Gammon

When Gammon won the Andover Historical Society 2008 Heritage Award, she said, "I love this town. I love the history of the town. That's why I've stayed involved as I have." To use the word "involved" when it comes to Gammon is an understatement. Besides being a selectman from 1979 to 1985, she was chair of the town's United States Bicentennial Celebration, chair of Andover's 350th Anniversary Committee, chair of the Andover Historical Society's 2011 Centennial Celebration, chair of the Memorial Hall Library Trustees, president of the Andover Historical Society, president of Kiwanis, treasurer of the Andonna Society, vice president of the League of Women Voters, and she was involved in church committees and the Girl Scouts. Gammon was the recipient of the Chamber of Commerce Community Service Award, the *Andover Townsman* Citizen of the Year Award, the Rotary Club Citizens Who Care Award, and Andover's Virginia Cole Community Service Award.

Her father was Harold Heseltine, who started Ford's Restaurant. ("Ford" was an associate's name.) He was involved in organizations having to do with the center merchants and was among the private group of merchants who first put up Christmas lighting. Norma's brother George Heseltine was a selectman from 1970 to 1976. He was president of the Andover Chamber of Commerce and chairman of the United Fund drive. He was awarded the Chamber of Commerce Community Service Award and was a founder of the Andover Hockey Association. George was the owner of Dana's Sport Shop on the corner of Main and Chestnut Streets. Charles Heseltine, another brother, has a long record of being involved in youth sports, notably as a hockey referee, and he worked at Dana's. His daughters, Amy and Kim, are mentioned in chapter three. (Courtesy of AHS.)

Sue Tucker

Before Tucker ran for office, she had been president of the Andover League of Women Voters and vice president of the Massachusetts League. She was teaching high school English when she took a job as a legislative aid, and, two years later, she was the first woman elected to the Massachusetts House from the 17th Essex House seat. In 1989, she was elected to the Massachusetts Senate and served in that position until retiring in 2010. While in the senate, she chaired three committees and provided excellent constituent service. (Courtesy of Susan Tucker.)

Barry Finegold

A political prodigy, Finegold (right) was elected selectman in 1995 at age 24. A year later, he was elected to the Massachusetts House of Representatives, and was the youngest member of the freshman class. Finegold was admitted to the Massachusetts Bar in 1998 and won the Kennedy School Fenn Award for Political Leadership in 1999, graduating from the school that year. Finegold was elected to the Massachusetts Senate in 2010 and was reelected in 2012. He represents all of Andover, as well as Dracut, Lawrence, and Tewksbury. (Courtesy of Barry Finegold.)

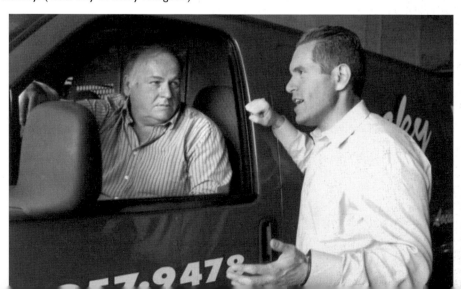

Charles H. Wesson

One of "Charlie" Wesson's six daughters said of her father: "Dad should be remembered as being rich in the qualities that mattered. He was kind, generous, considerate, patient, thoughtful, caring, honorable, and trustworthy." Wesson (1932–2009) was a selectman from 1983 to 1995 and served six years on the finance committee. He dedicated his life to his family, church, and community. Those who knew him would agree with his daughter's words. Charles and his wife, Mary (center), pose with their daughters: from left to right, Anne Marie, Elaine, Paula, Dana, Kathy, and Mary Ellen. (Courtesy of the Wesson family.)

Gerald H. Silverman (1933–2009)
The town's July Fourth fireworks are officially named "Jerry's Fireworks," because Gerald Silverman's efforts saved the event after town budget cuts. Silverman put collection bottles in public places, including stores, and asked for financial gifts. He served for 18 years as a selectman and was involved in numerous community causes, especially those helping youth. For decades, he and Charles Wesson were the closest of friends, running together for selectman, and visiting together, even in the final days of their lives. They passed away one month apart. (Courtesy of Myrna Silverman.)

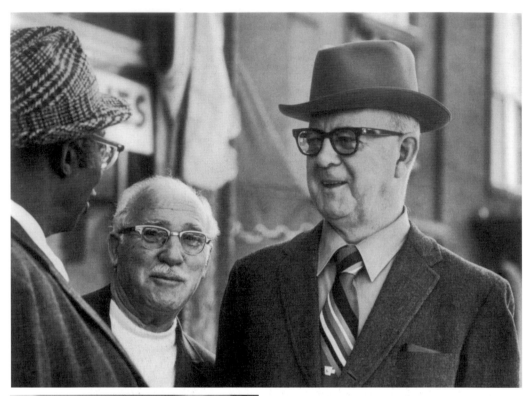

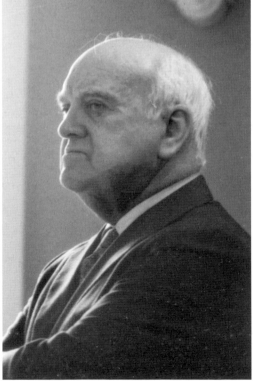

William Doherty, James D. Doherty
In 1934, at the height of the Great Depression, Bill Doherty, a reporter for the *Eagle-Tribune* and a member of the school committee, opened an insurance office in Andover. In 1937, he was joined by his brother Jim. A third brother, Joseph B. Doherty, was with them for several years. By 1953, they moved from an office in the Musgrove Building to the Simeone Block on Main Street and began selling real estate. In 1964, they moved the business into their own building, at 21 Elm Street. Beginning in 1931, Bill was on the school committee for 39 years, serving as secretary almost the entire time. Doherty School is named for him. Jim Doherty (1905–2009) was town moderator for 29 years, and received the Andover Historical Society's Heritage Award as well as the Rotary Club's Citizens Who Care Award. He wrote a 1992 book, *Andover as I Remember It*. Jim's children now run the business, and Sheila Doherty is the town moderator. In the above photograph, Bill Doherty (right) is seen with Fred Yancy (left) and Rocco Mirasola. Jim Doherty is pictured at left. (Photographs by Richard Graber, both courtesy of Jennifer Graber.)

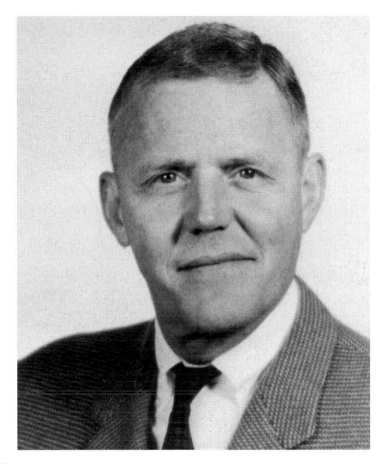

Philip K. Allen

Known as "PK" or "Phil," Phillip Allen (1910–1996) was one of Andover's most important citizens in the 20th century. The son of a Walpole industrialist, he began his connection with the town when he attended Phillips Academy. Not long after graduating from Yale, in 1933, he returned to PA as an English teacher and assistant basketball coach. Allen enlisted the year before World War II as a private in the Army and completed the war as a lieutenant colonel in the Office of Strategic Services (now the CIA). He gave Andover's first Memorial Day speech following the war. Later in 1946, he was elected to the state senate, serving for one term. Advocating for a town manager form of government, Allen was first elected selectman in 1959 for a two-year term, and later served from 1961 to 1970. He stayed involved in state politics and was the executive director of the state Republican Party and then its chairman. He held a key job in Gov. John A. Volpe's administration. In President Eisenhower's administration, he was a deputy assistant secretary of defense. Allen was a director at DASA Corporation, Bay Bank Merrimack Valley, and the Stratton Mountain Corp. He gave time and money to organizations he loved, such as the Boston Symphony Orchestra, the Community Music Center of Boston, and the Hurricane Island Outward Bound, and he became trustee emeritus of all three. He was good friends with Josh Miner, who brought Outward Bound to America. Allen served as an unpaid advisor to his many friends, some of whom were leaders in the state and community. For several years, Allen was a volunteer fundraiser for WGBH. Allen worked on many other local and state groups too numerous to mention. When Allen was chairman of the board of trustees at Abbot Academy, he was also a charter trustee at Phillips Academy. In this capacity, he was the perfect man in the perfect position to facilitate the merger of the two schools, which was done in 1973. Allen was congenial, smart, and knew how to get things done. (Courtesy of Phillips Academy Special Collections.)

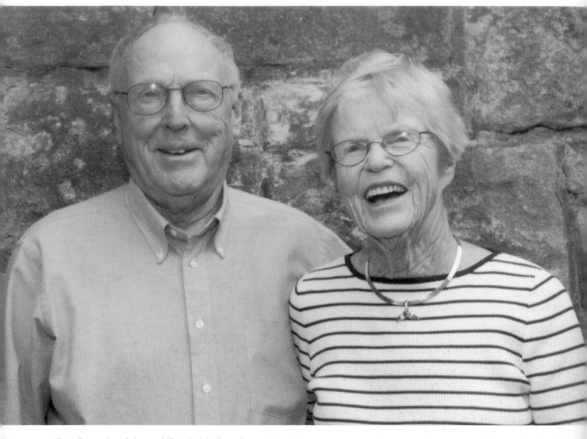

Dr. Douglas M. and Ruth H. Dunbar

Doug Dunbar served as a Navy corpsman attached to a Marine field hospital in the Pacific during World War II. In 1953, he opened a dental practice in Andover and soon became involved in the fluoridation fight, which led to a record 39 years on the board of health, many of them as chair. Known as "Doug" or "Doc," he was a coach, umpire, and player in baseball and softball at many levels. As a player, he was one of the best hitters on the field, even when other players were decades younger.

"Rusty" Dunbar moved to Andover when she married Doug in 1955, and by 1963, was president of the League of Women Voters. She served on numerous town committees, including 11 years on the finance committee, with three years as chair, and 11 years as a trustee of the library. The Dunbars received the Virginia Cole Community Service Award in 2007. (Courtesy of the Dunbar family.)

Frederick P. Fitzgerald

Walking most every day, Fitzgerald's route went all around Andover's center and then through it. If he saw people he knew, he often stopped and talked, sometimes for a quick check on how things were going, but often on more serious subjects. In 1989, he started discussing the need for a foundation to support Andover's public schools. Soon, the conversations became more specific, and he talked about starting a fund to support the schools. In 1991, Fitzgerald started the Andover Fund for Education (AFE). In order to encourage instructional innovation, AFE awards grants directly to teachers who are implementing new and creative projects. It sends grants to all 10 public schools in Andover. The fund holds an annual spelling bee and gives a scholarship award in Fitzgerald's name.

As an entrepreneur, Fitzgerald owned and operated a successful industrial tool company. When he did something, it was done right. A person who worked on a committee with him said, "He was the quiet guy who did more work than anyone and who was able to synthesize others' ideas. He made it easy for the rest of us. He was a very smart man." He was quick to smile and quick to laugh, even if it was at himself. He was on the school committee for three years (1963–1965). Fitzgerald believed in quality education and worked for it, but he would serve the town in any capacity if asked: from sitting on a town government study committee, to being on the finance committee, to working at the polls, he would never turn down an opportunity to help Andover.

Fitzgerald (1913–2008) was a gentleman and scholar who stayed out of the spotlight and was quick to give credit but never claim it. He read constantly and could, from memory, recite Tennyson's 238-line poem, Locksley Hall, when in his 90s. Fitzgerald was a person who could not be replaced. (Courtesy of Mark Spencer.)

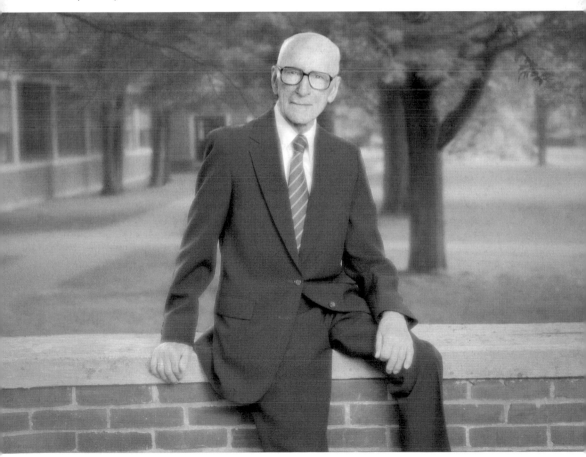

Benjamin H. Punchard
At his death, Punchard (1799–1850) left money in a trust, with instructions to build a "free school." At the suggestion of the town meeting, the trustees named it Punchard Free School. Andover's first public high school, it opened in 1856 with 56 boys and girls. In 1917, the last Punchard High School was built. The school's name was changed to Andover High School in 1957 when a new school building was opened on Shawsheen Road. The 1917 building (shown here) is now the town office building on Bartlett Street, at the intersection with Punchard Avenue. (Courtesy of AHS.)

Virginia H. Cole
In 2001, the town established an award for long-term community service in Virginia Cole's name, awarding it to her posthumously. She was on the school committee from 1964 to 1967, served on the School Study Committee, the Recreation Advisory Committee, and the Recycling Committee. Cole was president of the American Field Service Committee and the League of Women Voters, and was a selectman for one year (1978–1979). Her husband, Milton, managed Cole's Hardware Store. (Courtesy of Gail Ralston.)

Yvon Cormier
Cormier gave the town $1.5 million for the youth center, and he is a large contributor to other local and regional charities. He was one of 12 children when he left his native New Brunswick in the mid-1950s to come to the United States and work with his older brother. In 2008, the Legend of the Industry Award was given to Cormier by the Homebuilders Association of Massachusetts. The association stated that he came "with a hammer and saw, but these tools paled in comparison with his determination to succeed." He learned the building trade from the ground up, starting as a carpenter and framing subcontractor. He was an experienced homebuilder by the time he did his first Andover subdivision in 1975. In 1978, Cormier bought the Andover Country Club, including 350 acres of land. The country club was built by William Wood's American Woolen Company in 1924. At the time Cormier purchased it, the clubhouse was in a neglected condition, and the membership was dropping. Cormier is president of the club and has turned it into a top-notch place, and the course itself is annually ranked in the top 10 percent of New England country clubs. He created the Canadian Invitational Open Golf Tournament, now in its 30th year at the club. The tournament is a fundraiser for a range of charities, including the Jimmy Fund, Lazarus House, and Massachusetts General Hospital. Cormier owns commercial properties throughout Massachusetts, New Hampshire, and Vermont, and continues to build upscale homes near the Andover Country Club. He is a prime example of the American dream.(Courtesy of the Cormier family.)

Kay Berthold Frishman

After serving in the Peace Corps and at Head Start centers in New York City, Frishman moved back to Andover and worked at Family Service, Inc. for 30 years. As executive director for 25 years, she increased the staff from seven to fifty. She is a longtime volunteer with the Andover Village Improvement Society (AVIS), currently serving as clerk. Frishman graduated from Andover High in 1961, then Brown, and received a degree in social work from Columbia. In 2012, she won the Rotary Club of Andover Citizens Who Care Award. (Courtesy of Mark Spencer.)

Miriam Putnam (1904–1996)

Serving as the director of Memorial Hall Library from 1939 to 1967, Putnam oversaw the expansion of both the Children's Room in 1961 and the Reading Room in 1966. Called "Miss Putnam" by most people, including her contemporaries, this competent, friendly lady watched Memorial Hall grow from a small-town library to being headquarters for one of the regions of the Massachusetts library system. The Reading Room bears her name. (Courtesy of Memorial Hall Library.)

CHAPTER SIX

Conservation

Andover has one of the oldest and, no doubt, one of the best local conservation societies in the country. The Andover Village Improvement Society (AVIS) was formed in 1894 to fight such things as billboards, burning rubbish, and the improper disposal of trash. When these problems were mitigated, the society had no trouble moving to issues of conservation. Perhaps the most important factor in AVIS's success was that townspeople supported its mission. Another factor was that AVIS has a great number of quality volunteers. Although one volunteer, Harold Rafton, is most responsible for the acquisition of land under AVIS's management, there have been plenty of other people who have added to the success of the organization. AVIS is a nonprofit organization not funded by government.

The people who volunteer their time to the Andover Conservation Commission and the Andover Preservation Commission, both town government boards, should be remembered, as should the people who give land or sell it at a reduced price for conservation purposes. These people are epitomized by Tony and Gladys Sakowich, who, in 2012, gave the land for what is now called the Sakowich Reservation. In 1961, they bought valuable acreage adjoining their Oriole Drive home from a developer. Now in a retirement home, the Sakowiches had their house torn down and contributed the entire parcel to AVIS. They hope their gift will encourage other people to do the same.

Alice Buck

The rediscovery of Alice Buck's place in Andover history is as interesting as the story of how she saved Indian Ridge from being deforested. Indian Ridge, now a beautiful reservation, was considered such an important geological formation that scientists from all over the world came to see it in the 19th century. Buck (1842–1907) is credited with saving the land from locals who, in 1897, wanted to cut the pinewood for lumber. After a town meeting turned down the purchase of Indian Ridge, Buck organized a small committee of women to raise funds to buy the land. Although their efforts fell short, Buck was able to convince heirs of Hartwell Abbot, the owners of the land, to sell it at less than its market value. After Buck's death, John N. Cole, an original member of AVIS and the owner and editor of the *Andover Townsman*, wrote, "Years hence, the Indian Ridge Reservation will be a joy to the citizens of our little republic, but the people of that far off time will hardly know that they owe much of their pleasure to the gentle lady who died last week." He was almost right; she dropped off Andover's history until 1968, when Claus Dengler, president of AVIS, moved off the path near the top of Indian Ridge and spotted a plaque on a large boulder. It had bolts missing and was in a state of disrepair, but he could read it: "In memory of Miss Alice Buck, by whose loving interest and untiring exertion the perpetual use of this woodland was secured in 1897." The plaque has been twice cleaned and restored, and Buck's story has been renewed.

Buck was among the first members of the November Club, founded by Elizabeth Handy in 1889. The clubhouse was built in 1892 on Love Lane, now Locke Street, and it is in the National Register of Historic Places as being the first women's clubhouse in New England. According to the back of this photograph but perhaps not in exact order, those shown here are Mrs. Whitney, Mrs. Frederick Palmer, Mrs. Bachelder, Mrs. Whipple, Mrs. E.J. Hincks, Miss Kate A. Swift, Miss Alice Buck, Mrs. Lizzie A Gutterson, Mrs. George Moore, Miss Susan M. Blake, Mrs. Ellen C. Snow, Mrs. Ida M.M. Curdy, Mrs. Mary G. Perley, Mrs. Emily Carter, Mrs. Gayle M. Whittemore, and Mrs. S.C. Dove. (Courtesy of AHS.)

Frederick A. Stott and Susan Garth Stott

Everybody liked and respected Fred Stott (1917–2006) and paid attention when he spoke. He was born in Taylor Hall at Phillips Academy. His father taught English at PA, and Stott graduated from there in 1936 before going to Amherst and then joining the Marines, where he fought in the Pacific in World War II. At Kwajalein, Saipan, Tinian, and Iwo Jima, Stott saw some of the worst combat of the war. Earning the Navy Cross for extraordinary bravery, one of the nation's highest military honors, Stott also earned the Bronze Star and two Purple Hearts, becoming a major before being wounded and sent home. In 1951, he started work at PA in alumni affairs. In 1972, headmaster Ted Sizer named Stott secretary of the academy, and he was placed in charge of the school bicentennial fund, which raised $52 million, the highest amount of money raised by a secondary school to that time. He was on the town's conservation commission, the finance committee, and served as treasurer for Andover's 350th anniversary. Amherst gave him its Distinguished Service Award for Alumni Activities. Stott won every award the Appalachian Mountain Club could bestow, including its lifetime achievement award. When he was awarded the Andover Chamber of Commerce Community Service Award, presenter Michael Morris said, "There is a constant theme to Fred's life: he is clearly a person to be counted on." In 2004, at age 87, he published *On and Off the Trial: 70 Years with the Appalachian Mountain Club*. Fred's wife, Susan, graduated from Wellesley and then earned a master's degree from Harvard. She worked at PA for 22 years. Susan won the Andover Chamber of Commerce Community Service Award for her work with Andover Community Trust (ACT), of which she was a founding director. At the time of the writing of this book, ACT has started the process for its seventh permanently affordable home. She is a longtime trustee at AVIS. When Fred and Susan were awarded the Virginia Cole Community Service Award in 2003, it was noted, "They don't assume things are going to happen; they look for ways to make things happen." (Courtesy of Susan G. Stott.)

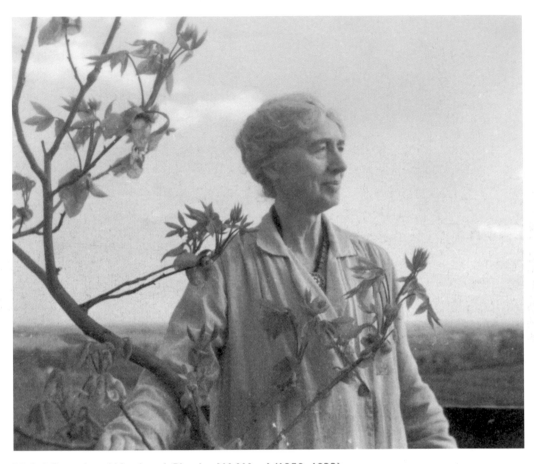

Mabel Saunders Ward and Charles W. Ward (1859–1933)

In 1917, Charles W. Ward retired, and he and his wife, Mabel Saunders Ward, purchased the old Holt Farm, which included 180 acres and an ancient home on the south side of the top of Holt Hill (called "Prospect Hill" by some). Holt Hill is the highest point in Essex County at 420 feet and has a clear view of Boston. The farm was settled originally by Nicholas Holt, and Holt is credited as being one of the first people to live in the South Parish, now called Andover. The original structure Holt built no longer exists, and the home the Wards moved into was built in 1714 by Timothy Holt, grandson of Nicholas. The last Holt to live there sold the farm in 1882. In 1898, a tornado destroyed two barns and damaged the home. The home was soon repaired, and one barn was rebuilt in 1902. During the time the Wards owned the land, it was improved by adding three fruit orchards and an assortment of animals. Charles took great pride in his apples, winning ribbons at the Topsfield Fair. In 1933, while he was picking apples, he died of a heart attack. In a 1927 letter to his family he wished ". . . the property could be used in a suitable manner for the benefit of some deserving organization . . . working for the benefit of young people." In 1940, Mabel deeded 156 acres to the Trustees of Reservations. Near that same time, she had stone markers placed at the top of the hill, indicating the primary compass directions and the setting sun of the solstices. She continued acquiring abutting land and deeding it to the trustees. When she died in 1956, the Charles W. Ward Reservation contained 280 acres. A month after her death, her grandson John Kimball was appointed chairman of the reservation's property committee, effectively making him steward of the reservation, and he continues in that role today. For many years the reservation has given countless individuals and families, including children, a place to walk and play. The top of Holt Hill is Andover's most beautiful location. (Courtesy of John W. and Margaret Kimball.)

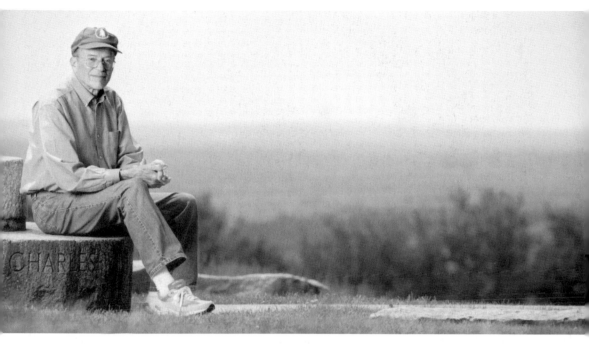

John W. Kimball, PhD

Dr. Kimball took over as steward of the Charles W. Ward Reservation in 1956. Since then, the Ward and Kimball families have increased the size of the reservation to 704 acres. A native Andoverian, Professor Kimball is retired from a career teaching biology at Phillips Academy, Harvard, and Tufts, where he was a tenured professor. Kimball's general biology text was first published in 1965, and the sixth edition appeared in 1994. He published books on cell biology and a widely used text on immunology. His books have been published in eight languages. (Above, courtesy of the Trustees of the Ward Reservation; below, courtesy of John W. Kimball.)

Harold R. Rafton and Helen Rafton, PhD

Although he was a clever entrepreneur and inventor who owned 150 patents, Harold Rafton is known as a conservationist. He and his wife, Helen (1890–1982), who held a doctorate in chemistry, moved to Andover in 1928. Helen joined the League of Women Voters, becoming its president. The Raftons began their careers as conservationists in 1955, when they sent a letter to the *Andover Townsman*. It was in response to a letter by Dan Hogan, a successful and respected businessman, who would later build Indian Ridge Country Club. Hogan's letter favored expansion and growth in Andover. The Rafton letter advocated the creation of publicly owned areas for recreation and that community planning should include multiple green areas. When Harold Rafton retired in 1958, he began the job of increasing the land holdings of AVIS. In 1955, AVIS owned 23 acres; when Rafton died in 1982, AVIS had under its control 850 acres, and he was responsible for much of that. Harold had legendary powers of persuasion that he used to good effect, convincing people to donate, bequeath, or sell their land for conservation. He worked to link parcels of land together, such as the Deer Jump Reservation along the Merrimack River. Deer Jump was obtained between 1960 and 1973, and Rafton considered its acquisition the most ambitious and rewarding of all his AVIS undertakings. Rafton was persuasive at town meetings as well. Usually sitting near the front with his wife, he would often speak against a particular development project or in favor of the town's acquisition of land. His pleasant face and demeanor belied his tenacity, whether in private or public conversation. The 226-acre Harold R. Rafton Reservation, named for him in 1968, is the largest of the AVIS reservations.

Phil Dargie, shown here at center with the Raftons, developed the warden system of managing land in Andover and was the AVIS warden of the Rafton Reservation. Dargie initiated and conducted the annual AVIS Cross Country Ski Race. This photograph was taken in 1975 for the *Andover Townsman* to advertise the race. (Courtesy of David Dargie.)

David Dargie and Nat Smith

David Dargie (left) took over the wardenship of the Rafton Reservation from his father in 1980, which included being director of the "Snowshoe and Cross Country Ski Trek" (formerly the cross country ski race). In January, 2013, the 44th event was held and Dargie has been to every one of them. In 1981, he became a member of the AVIS trustees and, in 2001, the first AVIS land manager. He has been the construction inspector for Town of Andover since 1982. In 2011, Dargie was awarded the Rotary Club's Citizens Who Care Award.

Nat Smith (right) was the recipient of the Virginia Cole Community Service Award in 2005. As president of AVIS for 35 years, Smith has raised money, made the familiar brown and yellow signs, written trail guide articles, taken photographs, and helped build boardwalks. At Phillips Academy from 1965 to 2005, he taught math, was a dean, a house counselor, coached squash and golf, and wrote math textbooks. Smith often recruited PA students to help clear AVIS trails. (Image courtesy of Nat Smith and David Dargie.)

Margaret "Peggy" Keck

Trustee emeritus Peggy Keck has been a volunteer for AVIS for more than 60 years, 20 of which were as chair for land acquisition. She served for 12 years on Andover's planning board, including serving as chair for three years. In 2005, AVIS named a 40-acre reservation in her honor. She was given the Virginia Cole Community Service Award and the Rotary Club Citizens Who Care Award. (Courtesy of Mark Spencer.)

Fred Snell

Snell discovered his love of hiking on a mountain behind the Pennsylvania home of his youth. After college, he brought this passion to Andover and joined the Andover committee of the Appalachian Mountain Club, becoming treasurer, vice chair, and then chair. Later, he became a trustee of AVIS, serving as president from 2005 to 2012. In addition to volunteering at his church, he facilitates the computer user's group at the senior center. In 2013, he won the Rotary Club's Citizens Who Care Award. (Courtesy of Fred Snell.)

CHAPTER SEVEN

Other Legendaries

Most of the people in this chapter either defy categorization or could be put in several categories. Andover has been fortunate in not having had many villainous residents; the only one featured in this chapter outsmarted justice. Mentioned here in passing are two others, neither of whom left behind a photographic likeness. The dastardly Huge Stone stabbed his wife in 1689. She lived; he was hanged. The deranged Mrs. Beard attacked her daughter and a friend with an axe in 1895. They survived, but the attack reminded authorities that Beard had lost two children in an earlier, suspicious house fire. She died in an asylum.

Not featured in this chapter because so much information is readily available in other sources are favorite son Jay Leno, from Ballardvale, and television actor Michael Chiklis, who was once captain of the Andover High football team. Also not featured, as their only connection with Andover is having attended school here, are Academy Award–winning actor Humphrey Bogart (PA '20), Oscar-winner Jack Lemmon (PA '43), and America's most important landscape architect, Frederick Law Olmsted (PA 1838).

Martha and Thomas Carrier

The Carriers were the most unusual couple in Andover's history. Martha Carrier spoke her mind long before women did such things. She and her husband, Thomas Carrier, who was seven feet, four inches tall, owned land next to Benjamin Abbot, who later built what is known as the Old Abbot Homestead. Martha and Abbot disputed a boundary, and Abbot developed boils. When one of them was lanced, it was said that gallons of pus poured out. He accused Martha of being a witch. Her two young sons, upon being tortured, testified against her, and her seven-year-old daughter agreed with her brothers. Martha never backed down, telling the judges, "You lie, I am wronged." Cotton Mather called her a "rampant hag . . . the Queen of Hell." She was hanged in 1692 and buried in a shallow grave. It is not known if her husband dug her body out and brought it home to Andover.

It is also not known what Thomas Carrier did during all of his family's travails, but historian Sarah Loring Bailey wrote that he seemed to be blessed with a "comfortable temperament [for he had] sorrows enough to have brought some men to a premature grave. He lived to an age of 109 years." His family said it was 113 years. In his 70s, Thomas moved his children and became one of the first settlers of Marlborough, Connecticut, where he became a successful gristmill owner and the town's largest landowner. In 1735, the *New England Journal*, reporting his death at age 109, stated he was neither bald nor grey and "not many days before his death he walked six miles to visit a sick friend and the day before he died he visited neighbors. His mind was alert until he died, when he fell asleep in his chair and never woke up." It had long been his practice to walk 18 miles a day to the market and back, half of the distance with a large sack of meal over his shoulder. There is some evidence that Thomas Carrier once had a Welsh name and, picked for his size, was an executioner of King Charles I of England. Either Carrier could have been considered unusual; as a couple, they were historically extraordinary. (Courtesy of Don Kennedy Photography.)

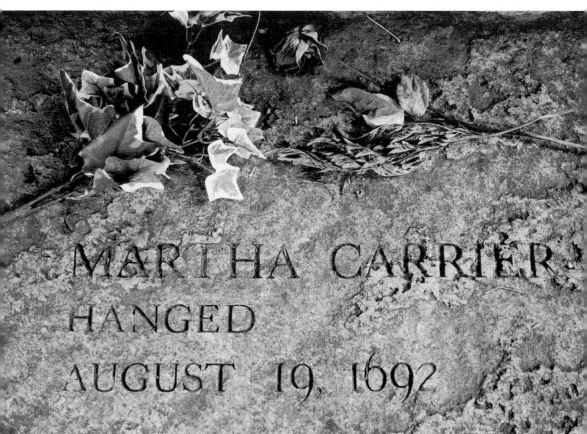

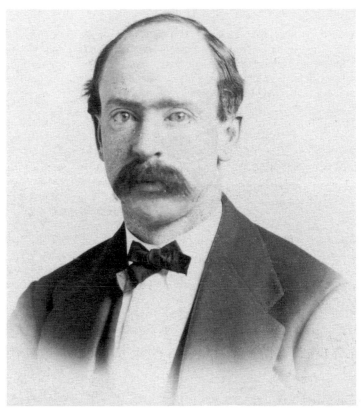

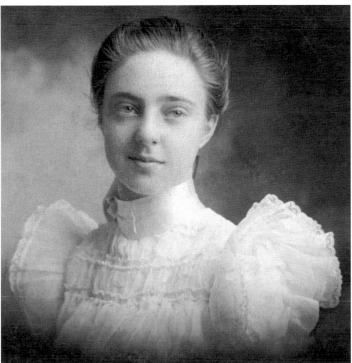

William G. Goldsmith and Bessie Punchard Goldsmith William Goldsmith (1832–1910) was the head of Punchard Free School (eventually known as Punchard High School) from 1858 to 1886, excepting a year as principal of Phillips Academy. The strict but popular Goldsmith, who set the tone for Punchard's academic excellence, asked his students to choose a middle name for his daughter, Bessie, and they chose "Punchard," to honor their school. He resigned to be postmaster. In 1894, he was elected the first president of AVIS, and from 1898 to 1901 he was a selectman. Bessie Punchard Goldsmith (1882–1974) was an interesting person, to say the least. At times cantankerous, she was always brilliant and often the center of attention. A historian and *Andover Townsman* columnist, she authored *The Townswoman's Andover* (1964). An on-call policewoman, Bessie Goldsmith was equally comfortable scaring blueberry pickers off her land with a rifle, teaching home economics at Punchard, and being at the Garden Club. She left the 130-acre Goldsmith Reservation to AVIS. (Both, courtesy of AHS.)

Susan Lenoe
A storyteller and actress, Susan Lenoe specializes in portraying Andover women in history, including Harriet Beecher Stowe, Anne Bradstreet, and Alice Buck. She holds a degree in English and drama from Barnard College and has won numerous awards, including Best Supporting Actress at the New England Community Theater Conference and an award from the Andover Preservation Commission "for bringing history to life through her interpretation of Andover's historical characters." Lenoe presents a weekly story hour at the Andover Bookstore. (Courtesy of Ed Pedi.)

George D. LeMaitre, MD
Currently a clinical instructor at Tufts Medical School and the founder-chairman of LeMaitre Vascular, Inc., a medical device company in Burlington, LeMaitre practiced general and vascular surgery from 1964 to 1997. He was chief of surgery at Lawrence General Hospital and later was president of the medical staff at Holy Family Hospital. He published numerous articles and books, including a surgical textbook and *How to Choose a Good Doctor*. He is pictured with his wife, Connie. (Courtesy of the LeMaitre family.)

Job Tyler

Historian Sarah Loring Bailey wrote of a "tradition" that Job Tyler was in Andover before the first official settlers. This motivated the Tyler descendants to put a plaque in the old burial ground in North Andover in 1901. Tyler was certainly in Andover by 1648, when his wife was the victim of an accused witch, John Godfrey, who supposedly caused "a bird to come to suck the wife of Job Tyler." Godfrey was found innocent. Tyler then got into a protracted, 10-year lawsuit with Thomas Chandler. Tyler lost, by which time he was a pauper living in Roxbury. (Courtesy of the authors.)

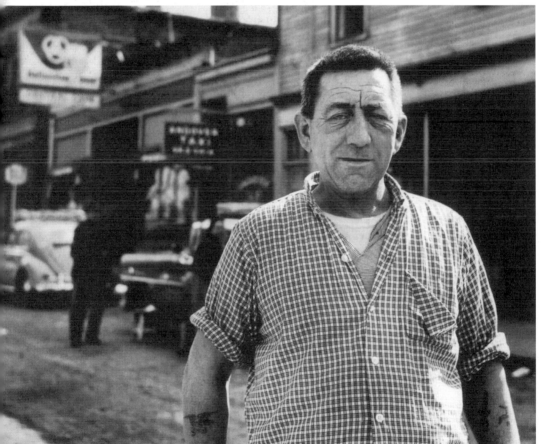

Meckah McCord

McCord was a veteran of World War II. When he came home, he swore he'd never work again, and to the best of anyone's knowledge, he never did. However, he was a likeable fixture around Elm Square in the 1950s and 1960s. McCord is shown standing on an unpaved Post Office Avenue in 1963, a time when the buildings were run-down and the avenue contained two townies-only bars. (Photograph by Richard Graber; courtesy of Jennifer Graber.)

Joseph Hardy Neesima

Although it was illegal for him to leave Japan, Neesima (1843–1890) came to America on a ship owned by Alpheus Hardy, a trustee at Phillips Academy who became Neesima's patron. Already nicknamed "Joe," Neesima adopted the name Joseph Hardy Neesima to honor Hardy. Neesima graduated from Phillips Academy in 1868, then attended Amherst College and Andover Theological Seminary. Neesima became the first Japanese to receive a degree in the Americas. In Andover, he boarded with the Hidden family of Hidden Road. He returned to Japan, where he founded Doshisha University, one of Japan's great schools. (Courtesy of Phillips Academy Special Collections.)

Pompey Lovejoy and Rose Foster Lovejoy

The Lovejoys, former slaves of Andover families, were married in 1751. They were granted land near Pomp's Pond, which is named for Pompey (1724–1826). Well into middle age, he served in the Revolutionary War and was given a small pension. On election days, Rose baked cakes, serving them near their home. Pompey lived to be 102, and his epitaph reads, "Born in Boston a slave / Died in Andover a free man / Much respected as a sensible / amiable upright man." Rose died soon after, at 98. (Courtesy of Donna Mrozowski.)

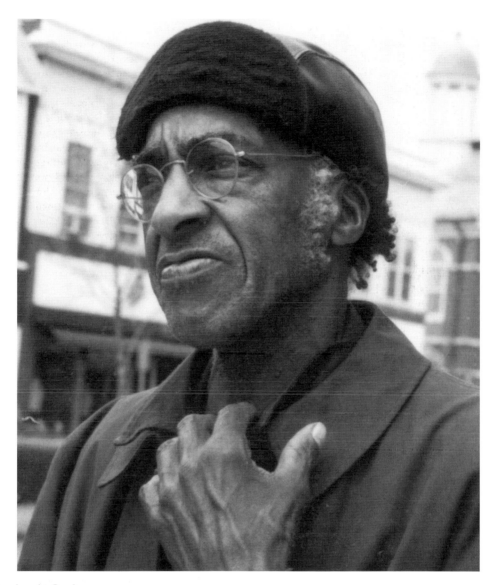

Benjamin Sayles
Sayles (1922–2003) was a pleasing fixture in the town's center for many years, standing at Park and Main Streets with his foot on the fire hydrant, talking with folks as they walked by. He was a landscaper by trade and a lifelong member of the NAACP Membership Committee, and he persuaded many merchants to become members. As a young man, Sayles drove a 1944 motorcycle and wore a leather jacket with the words "Benny Who Cares" on the back. When he got older, he traded his motorcycle for a red pickup truck to carry his landscaping equipment. The truck became picturesque with age, carrying its dings and dents with honor. Sayles's Salem Street house, where he lived with his brother Marvin, was the first place neighborhood kids visited on Halloween since the Sayles brothers had so many goodies that they filled a large dining room table. Ben often brought ice cream to the fire station and joined the evening crew as they watched television. Everyone liked him. Retired fire chief Harold Hayes said, "Ben was a kind-hearted, hard-working gentleman. When he spoke with his fast way of talking you were captured by his enthusiasm for life. He made the world around him a more joyful place to be. God bless him." (Photograph by Richard Graber, courtesy of Jennifer Graber.)

Phidias Dantos

Phid Dantos and John Davidson (see page 113) have several things in common: they were born during the Depression, their families were recent arrivals in the country, they both worked hard from a young age, and they were both adventurous. In the case of Dantos, he learned to fly as a young adult and had enough exploits to fill a book. On one harrowing occasion, he found himself over the Haiti airport in the dark, and the airport had no lights. Unable to communicate by radio, he circled the area, and, somewhat miraculously, the authorities garnered enough cars to light the runway, allowing Dantos to land. Although it was illegal to land after dark, and Haiti was a dangerous place ruled by a brutal despot, Dantos ingratiated himself to the authorities to such a degree that they posted a sentry on his plane while he vacationed for a week.

Dantos's father, mother, and uncle were Greek immigrants. George, his father, and Pete, his uncle (far right), worked hard enough to open a store of their own in 1921. Although they called it the Andover Spa, the public called the store "Pete's," as he was the gregarious one. The business thrived, and Pete outlived George. After graduating from Punchard and serving a stint in the Navy, Phid Dantos returned home and took over half the business. Soon, he owned it all. He added his own gregarious personality and was a good businessman. Importantly, he made sure Andover had enough coconuts on Memorial Day.

Dantos and John Davidson, business partners working through Danton Realty Trust, which they owned, changed the face of Andover's center. Then, they took on their biggest project. Paul Cronin was Andover's state representative and had once worked at Pete's. Dantos and Cronin were good friends, and Cronin told Dantos that Raytheon had called him to say they were planning to move to New Hampshire from their location in Shawsheen, which would mean Andover would lose its biggest taxpayer. Danton Realty Trust owned 220 acres near Interstate 93. Dantos and Davidson abandoned their plan to build an office park on the land and went to Raytheon. The result was the biggest town meeting in Andover's history and an overwhelming rezoning vote that allowed Danton Realty Trust to move Raytheon to Danton's property. Phidias Dantos went on to serve as a state aeronautic commissioner and to own and operate a 10-store Au Bon Pain franchise. He and John Davidson remain good friends to this day. (Courtesy of AHS.)

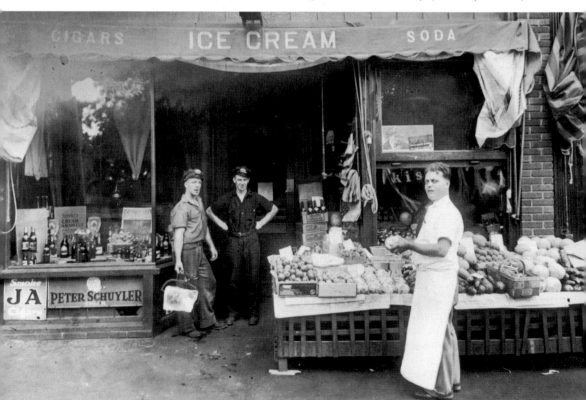

L. John Davidson

One morning, Davidson (left) threw a chair through a window to emphasize a point he was making to his business partner, Phid Dantos (right). Dantos quickly walked out of the office. A few hours later, Davidson, as if nothing had happened, called and asked Dantos if he was coming to the office. The window was already repaired when Dantos returned, and they continued their discussion.

Davidson's grandparents, Armenian immigrants, bought a farm near what is now the 17th hole of the Andover Country Club. Davidson's father, Leon, would one day own the club. In 1925, Leon purchased 125–127 Main Street, a building that has the name "Leons" above the large windows on the right, although many simply know it as the Andover Shop Building. Leon's was the name of a restaurant at 125 Main Street, although it was commonly called "Doc's," a nickname Leon Davidson earned while driving an ambulance in World War I. (Later, when the Birdsall family owned the business, it was called the Coffee Mill.) John Davidson waited tables at Doc's beginning at age 10 and went to Phillips Academy and Harvard. After a tour in the Air Force, he worked at the Andover Shop, a clothing store his father had purchased. While still in his 20s, Davidson, perhaps bored, went to search for a lost Mexican gold mine, taking two other townies. They explored the jungle with no success, but the highlight of the trip occurred when a drunken guide vehemently disagreed with Davidson while holding a gun to his head. Years later, Davidson was interviewed on the *Today Show* after he'd found a sunken treasure ship, the *DeBraak*. However, the few coins recovered didn't pay for the expedition.

Davidson and Dantos first worked together to defeat urban renewal in Andover. After that long, successful fight, they formed Danton Realty Trust. It was hard work, often taking them close to failure, but they persevered and succeeded. Their first project was One Elm Square, a new structure, followed by 90 Main Street, which required renovation and tenants. After other downtown projects, they tackled their biggest project, Raytheon (see page 112). Following the work in Andover, Davidson developed Quechee Lakes in Quechee, Vermont. South Down Shores in Laconia, New Hampshire, followed, and today he is perfecting a patent he holds on the pasteurization of eggs. (Image courtesy of Phidias Dantos.)

Frances Packard McClellan

Frances Packard (1880–1971) was born to a comfortable family, studied art in Europe, and returned to the United States with ambitions to be an artist. Love interceded, and she became Mrs. Percy McClellan. At 36, she was happy and living on a large farm in Haverhill with her husband and six young children. However, tragedy struck: her husband was kicked in the head by a horse and died. Frances sold the farm and came to Andover to temporarily live with her mother, Elizabeth Packard, at 1 Orchard Street. Soon thereafter, Frances built an Addison LeBoutillier–designed house behind her mother's. It was there that Frances raised her children and would live the rest of her life. In 1930, then age 50, she opened the McClellan Gift Shop in her house. At first, the inventory included family heirlooms and antiques, an indication that the shop was a financial necessity for her. From her earlier art training, McClellan was a skilled watercolorist and sold her paintings from the shop, which she ran until the day she died at age 91.

Her last child, Francis McClellan, passed away at age 101 in 2013. For his exploits as a pilot in the Army Air Force in World War II, he received one of the country's highest honors, the Distinguished Flying Cross. Prior to the United States entering the war, he had served as a pilot for the Royal Canadian Air Force, at one time leading his bomber crew on a 21-day trek to safety after the plane crashed. Another son, John, a graduate of Phillips Academy, fought in the war with the 10th Mountain Division (the famous "soldiers on skis") at the vicious battles for Riva Ridge in the Italian Alps. He earned two Purple Hearts in two weeks. A third son, James, served in the Philippines during the war. James became a sculptor, and many of his works are on display at the Cape Ann Museum. Hugh, the fourth son, went to PA, Yale, and MIT and worked as an architect. George, a Punchard graduate, operated an interstate trucking company. The only daughter, Elizabeth, went to Abbot, Smith, and MIT, where she was second in her class. While touring Europe, she met her future husband, Loris Stefani. They married and settled back in Andover. Of their three surviving children, Robert lives in Andover in his grandmother's house. Shown here are, from left to right, James, Frances (holding baby George), Hugh, and Francis (on top of snow roller). (Courtesy of Robert Stefani.)

Mary E. Dalton

Suddenly widowed in 1908, Dalton moved herself and her four young children to Andover, assuming ownership of the Metropolitan, a Main Street bakery, ice-cream shop, and employment agency. Dalton identified people in dire need, and, in turn, Mary Wentworth French, a wealthy Andover woman, anonymously provided assistance. Dalton's oldest son died as a young man. Another son, Charles, later owned Dalton's Pharmacy. Her son Bill was one of the best athletes to play at Punchard, earning scholarships to PA and Bates College. Dalton's daughter, Frances, was an artist and head of the Andover Schools art department. (Courtesy of the authors.)

Sarkis and Rita Sarkisian

After the death of his father, Ovogen, in 1968, Sarkis, with his wife, Rita, took over the farming business that his immigrant father started in 1932. As the economics of farming changed, the Sarkisians added a retail strawberry and flower business to the farm. When the economics of retailing changed, so did the Sarkisians' vision. In 1994, they put in a golf range and then added an ice-cream stand. Located on Chandler Road, it is a beautiful location visited by many. (Courtesy of the Sarkisian family.)

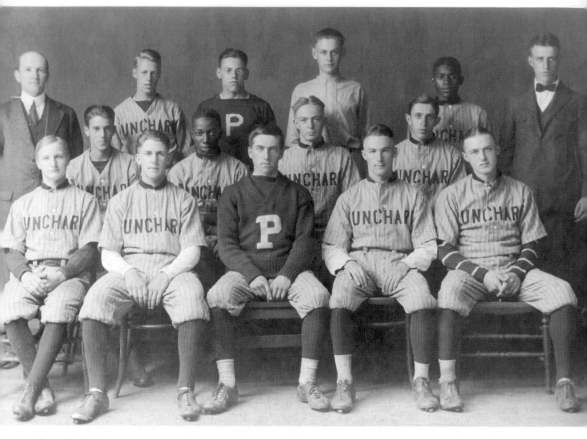

Leo F. Daley

Graduating from Punchard and Phillips Academy, Daley (1900–1991) went on to Harvard ('27). He was president of his senior class at both PA and Harvard. With scholarship offers from several schools, he went to Yale for a week, said he was bored, and quickly moved into Harvard. As an investment banker, he was so highly regarded that, when he decided to change companies, his longtime secretary said he immediately had 44 job offers.

Growing up, he was the unofficial leader of the "Dalton Gang," which included Charles and Bill Dalton, Harry Payne, and two or three others. This group of kids played sports and hung out together at the Playstead and the Park. An outstanding athlete, Daley was inducted into the Punchard-Andover Hall of Fame. He lived in Andover all his life, serving on the finance committee and on the boards of the library, Spring Grove Cemetery, and Red Cross. He served the town's retirement board as a volunteer investment advisor for 20 years, until he was 90. Daley was respected, generous, well liked, and had a fine sense of humor.

The undefeated 1918 Punchard football team posed for a photograph. Shown are, from left to right, (first row) Dimlich, J. Holland, Sol Walker (captain), W. Cronin, and Roy Bowman; (second row) Partridge, Chandler, Lindsay, and W. McKee; (third row) coach Eugene "Pop" Lovely, sophomore Bill Dalton, junior Charlie Dalton, R. Webster, Harry Payne, and Leo Daley. The varsity football field is named for Coach Lovely. Bill Dalton was the second person inducted into the Punchard-Andover Hall of Fame. Charlie Dalton was the quarterback for two consecutive undefeated seasons, and he is also in the Punchard-Andover Hall of Fame, along with Leo Daley. (Courtesy of the authors.)

Jane and Benjamin Pierce

This beautiful photograph was taken of Jane Pierce, wife of future president Franklin Pierce, and their last surviving child, Bennie, c. 1851. From the earlier loss of two children, Jane Pierce understandably suffered from depression, so Franklin retired from Congress and returned home to Concord, New Hampshire. Mary Aiken, Jane's sister, lived at 48 Central Street in Andover with her husband, John. The Pierces visited them often, and Bennie was sent to Phillips Academy. To Jane's great displeasure, a deadlocked Democratic convention caused Pierce to be nominated and then elected president. On January 6, 1853, two months before his inauguration, the Pierces boarded a train from Andover to Concord. It derailed near Frye Village, now called Shawsheen, and 11-year-old Bennie suffered a severe head wound and died in front of his parents. Jane would repeatedly say Bennie was the price God exacted for Franklin becoming president. The sadness that befell the Pierces no doubt contributed to the bleakness of the Pierce presidency. The Aiken's home was the summer White House during Pierce's term. (Courtesy of Pierce Brigade.)

George "Baron" Connors

A great conversationalist and a great guy, Connors (1918–2002) was nicknamed when a coworker started calling him "Baron" after Baron Munchhausen, famous for storytelling. In 1949, Connors organized CYO baseball. In the 1950s, he coached the town's second Little League team and church league basketball. He was one of the original coaches of Andover Youth Football in the 1960s. For most of the 1950s and up to 1964, when it ended, Twilight League baseball was umpired by the colorful Connors. He was such a nice guy that, if he made a bad call, the victim would never argue, although the player might make a brief comment, to which Connors would laughingly respond, "No, no, no, no, no." A big, muscular guy, Connors was a gentle man. When he lost the lower part of a leg in 1978, Connors became a regular in the town's center. People who knew him, and there were many, would go out of their way to speak with him and trade stories.

His son, Barry Connors, is a fine storyteller as well. He was co-captain and MVP on his Andover High School football and basketball teams. After playing college football on a scholarship, he signed with the Cleveland Browns and then played semipro football in the Eastern League. He was a teacher and coached football, basketball, and wrestling in Billerica from 1969 until he retired in 2002. Barry lived in Andover during these years. Shown here are, from left to right, (first row) Joe Lynch, George Connors Jr., and Joe Morgan; (second row) John Matten, Ron Bergeron, George "Baron" Connors, Jimmy Sullivan, and George Walsh; (third row) Charles Lynch, Dave Hannon, and Billy Vickers. (Courtesy of George and Martha Walsh.)

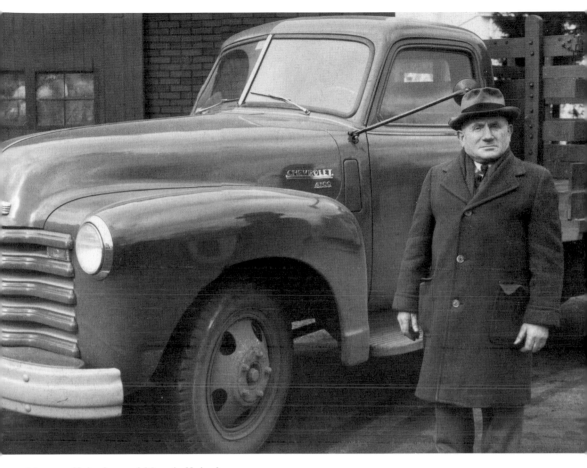

Hyman Krinsky and Morris Krinsky

In the middle of the 20th century, the legend among Andover children was that either Hyman (pictured) or his son, Morris, could pick up the front of the truck shown here. Kids would hide in the bushes near Krinsky's junkyard, waiting to see such feats of strength. The legend may have been created at Pomp's Pond, where Morris, as a young man, used the diving board to do athletic tricks. He, like his father, was short and powerfully built. Hyman emigrated from Russia in 1916 and opened the junkyard in the mid-1920s. To most longtime residents, the junkyard was picturesque, often a convenience, but to some newer folks, it was an eyesore. At one town meeting, someone disparaged the junkyard, and an audible whisper of displeasure caused the speaker to look at the crowd. Morris graduated from Punchard in 1934 and did winter work at Florida racetracks for several years. Hyman died in 1973. After Morris suffered a stroke in 1983, and until he died in 1996, he sat each day in the junkyard, speaking to friends and neighbors and watching the town pass by. (Courtesy of AHS.)

Robert E. McQuade

A big man with a big smile and laugh, McQuade (1928–2013) was the longtime director of public works and he was easy to notice in a crowd. He created a water and sewer infrastructure that would support future residential and industrial expansion, and the water treatment plant, a state-of-the-art facility, was named for him in 1991. McQuade was a World War II and Korean War veteran. He is pictured here with his wife, Ruth. (Courtesy of Ruth C. McQuade.)

David MacDonald

MacDonald's parents emigrated from Scotland to work in the mills. David graduated from Punchard in 1941, fought for his country in World War II, and was wounded aboard the USS *Yorktown*. After several surgeries to repair the wound, he married Ruth Anderson and became a banker. In 1978, they bought the Ad King, an advertising business. They made it a success, and it became a family business, now run by a son and grandson. Ruth died in 2001, and Peter, one of their sons, passed away in 2011. Pictured here are David's half-brother John Murray (left), his wife, Mary-Jo Varnum Murray (center), and Dave MacDonald. (Courtesy of Rosemary MacDonald.)

Chester Darling, Esq.

Chester Darling of Andover is now blind and in his 80s, but he is still practicing law. He says, "My focus has always been motivated by my need to push back whenever government or others abuse their authority inflicting injury to those who don't have the keys to the courthouse." He calls himself the "Lawyer for Lost Causes," and he represents people of all persuasions, often for little or no money. In 1995, Darling won a landmark First Amendment case. He argued before the US Supreme Court and won a unanimous ruling. Darling's client was the group that ran South Boston's St. Patrick's Day Parade. The other side was a gay, lesbian, and bisexual alliance that wanted to be in the parade to communicate its message. In Massachusetts, the case went against Darling's politically unpopular client, and the Massachusetts Supreme Judicial Court overwhelming ruled against them. The other party was receiving pro bono help from several major Boston firms that threw motion after motion at Darling, who was alone in representing his client, receiving very little payment. He had to give up the rest of his practice to handle the paperwork, and by the time he appeared before the Supreme Court, he was broke. His wife, Daphne, who is also his assistant, never flinched, backing him completely. The rulings in Massachusetts forced Darling's clients to either accept a message opposed to their values or not hold the parade. However, Justice David Souter, writing for the Supreme Court, said, "Our holding today rests not on any particular view about [Darling's client's] message but on the Nation's commitment to protect freedom of speech. Disapproval of a private speaker's views does not legitimize use of the Commonwealth's power to alter the message by including one or more [messages] acceptable to others." Prof. Charles E. Rounds of Suffolk Law School wrote, "Darling now stands in the state's pantheon of legal luminaries, perhaps next to John Adams." *Lawyers Weekly* praised Darling: "His practice suffered, and he was subject to ridicule and private harassment. Nevertheless, he persisted." Shortly after that case, Darling represented a gay group before the Lawrence City Council. Darling was appealing the denial of a permit for the group to stage a gay pride parade. He persuaded the council to grant the permit but needed a police escort to his car. (Courtesy of Chester and Daphne Darling.)

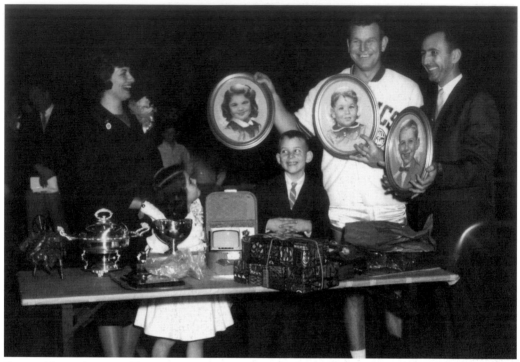

Jim and Lynn Loscutoff

Camp Evergreen, next to Harold Parker Forest, was opened in 1964 by the Loscutoffs. Jim (second from right in the above photograph) played for the Celtics from 1955 to 1964. He collected seven NBA championship rings and was nicknamed "Jungle Jim" by the press because of his bruising style of play. His other nickname, "Loscy," is on a Celtic shirt in the Boston Garden rafters alongside those of other Celtic greats. Lynn (at left in the above photograph, and below) is an artist, art teacher, and writer, with studios in Andover and Gloucester, and her paintings have been exhibited 21 times. She served as executive director of the Copley Society in Boston, and is one of only five people in 100 years to receive the Copley Medal for Distinguished Service to the Arts in Boston. Camp Evergreen is now overseen by the Loscutoffs' son Jim. The camp celebrates its 50th anniversary in 2014. (Both, courtesy of the Loscutoff family.)

Thomas Low

Low (1911–2008) was both an athlete and a musician. He was president of the glee club and captained his Punchard High School baseball team in 1931, the year he graduated. He tried out for the Boston Braves, played semipro baseball for years, and was on the Tyer Rubber team. As a violinist, he played with the big bands that appeared at the Crystal Ballroom and Balmoral Spa. For decades, Low played at the old Square and Compass Club, usually at Scottish dances, and he sang for the Andover Choral Society and Free Church choir. He was a champion golfer at Longmeadow Country Club and was the first manager in Andover Little League. Tom's son Barry graduated from Andover High School. After college, he played for the US Navy Band and taught music education for 40 years.

In the above photograph, Barry (left) and Tom pose with their instruments. Below, Little League manager Tom Low coaches Robert Shaughnessy as Mickey McCormack watches on the left. (Both, courtesy of Barry Low.)

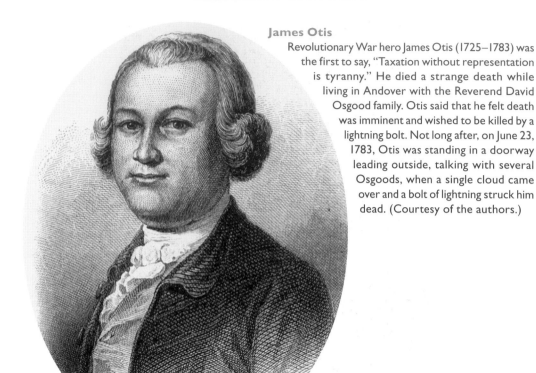

James Otis
Revolutionary War hero James Otis (1725–1783) was the first to say, "Taxation without representation is tyranny." He died a strange death while living in Andover with the Reverend David Osgood family. Otis said that he felt death was imminent and wished to be killed by a lightning bolt. Not long after, on June 23, 1783, Otis was standing in a doorway leading outside, talking with several Osgoods, when a single cloud came over and a bolt of lightning struck him dead. (Courtesy of the authors.)

Randall L. Hanson
"Randy" Hanson, competent and pleasant, was a fine example of a government employee. Hanson was Andover's town clerk from 1990 to 2010. Prior to that, she worked in marketing at the Andover Bank, and she was president of the Andover Downtown Association from 1984 to 1987. She is happy in her well-deserved retirement. (Courtesy of Randy Hanson.)

Bessie Mae Wilkins Skeels Lundgren

In June 1919, a sensational murder trial made headlines around the country. Bessie Mae Wilkins was charged for the murder, by arsenic, of Florence Gay, daughter of a prominent Andover family. Bessie's real age, like much of her life, is murky. Various documents show she was born in 1869, or 1882; her headstone at Spring Grove Cemetery reads 1876. She emigrated from England and, at age 15, married a man who, she said, later deserted her. Her second husband was Frank Skeels, her married employer in Ohio. (She claimed they wed in 1896, until the first Mrs. Skeels dramatically appeared out of nowhere at the murder trial, waving a 1901 divorce by desertion decree.) Bessie and Frank Skeels were living in Lawrence when he died of "bowel obstruction" in 1908, leaving her a decent inheritance.

Bessie was in Bayonne, New Jersey, in 1916, visiting her family, when her father suddenly died. She returned to Andover the next month and became a nurse to Florence Gay, who took a sudden downturn in November 1917 and died. With rumors swirling in town that Bessie had been stealing from the Gays, she returned to Bayonne in February 1918. Then, her mother died in April. In July, her brother and her sister-in-law died. She returned to Andover on August 28, and her fiancé, Alfred Lundgren, warned her that she was to be arrested for theft. The next day, originally planned for their wedding, police arrived at her boardinghouse at 60 Chestnut Street, and Bessie attempted suicide by putting her mouth over a gascock. She was in the hospital for a year with various maladies. Meanwhile, the theft case evolved into a murder charge. New Jersey authorities also indicted her in December 1918 for the poisoning of her brother. Forever loyal, Alfred married her in March 1919 at the hospital bedside, insisting daily to the press that she was about to die. The trial began in June 1919, and by press accounts, it was outrageous, with Bessie carried in and propped up on pillows, and a judge so deferential to her that the trial day often lasted only a few hours. She was acquitted on July 3, and New Jersey authorities immediately announced their plans to extradite her. For months, Alfred issued press releases stating that her death was imminent. The New Jersey charges faded away, perhaps because Bessie was apparently almost dead. She lived uneventfully in Andover for another 24 years, and for once, somebody close outlived her; Alfred died 18 years after her. (Courtesy of Boston Public Library.)

INDEX

Find more books like this at
www.legendarylocals.com

Discover more local and regional history books at
www.arcadiapublishing.com